AS I SEE IT

A Life in Detours

TRIGLYPH
BOOKS

AS I SEE IT
A Life in Detours

Words and photography by
Thomas A. Kligerman

TRIGLYPH
BOOKS

A Life in Detours

Every year I take a month off to travel. I swap out my SIM card so the phone has a different number and nobody can get hold of me apart from a very select few. People are shocked when I tell them that I disappear for so long, but I believe that it's good for me because it recharges my imagination; and ultimately it's good for what we do, which is designing homes. And it's good for the office because it gives my colleagues more responsibility and autonomy. I have always traveled. My family changed houses so often when I was young that always being in motion has become a habit – a rolling stone.

I was on sabbatical in India when Covid hit; I returned home earlier than planned. Travel would not be easily accessible for the remainder of the year as the pandemic raged on. Instead, like millions of fellow humans whose spirit of adventure had been temporarily bottled up, I traveled in my mind. In my case this meant looking through the multitude of images on my phone and posting the best of them on Instagram. *A Life In Detours* comes as a direct result of that escapism. I would be the first to admit that there is an irony here. Instagram is part of the world of social media that has transformed the way we consume media. It is spontaneous, ephemeral – the opposite of everything you would associate with an actual book.

Who needs books these days? Not the client who was shocked to find I had included bookshelves in the library designed for him. He had no use for them; he could get everything he wanted to read on his iPad. Despite all of this I can't help but maintain an immense affection for physical books – they are an indispensable part of my life. It's like going to a concert.

You can get all the music you'd like to hear on Spotify or Apple Music, but nothing can totally replace live performance. Something I think even the Zoomers can agree with. We have 6,000 volumes of books in my office, two of which I co-authored. I could no more lead a life without books than I could live without travel.

I am pleased that in *A Life in Detours* social media can feed my book obsession by producing something of a cross-over. Not that *A Life in Detours* turns its back on the digisphere: on the contrary it uses the internet to enrich the readers' experience by means of QR codes that appear throughout the book. Point your phone at the codes and they'll link to sites that provide more information, more photographs, more things to inspire you, or learn about the places I've seen. I won't say where each code will take you in advance. Where you end up will be a surprise, I hope a pleasant one — and isn't that the essence of travel?

8

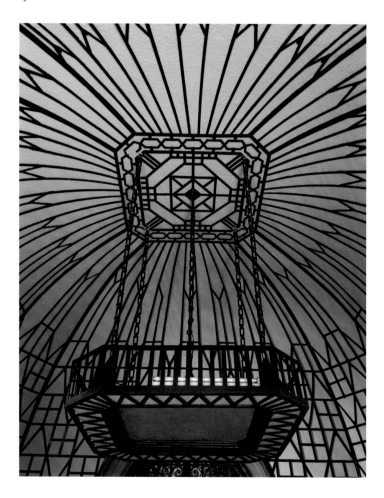

tomkligerman Havana is full of the most amazing architecture.
Buildings from the deco era, the classical era, the late 19th century
and beyond. Some are huge and elaborate, others are intimate and
charming. But the space that stands out most for me is this porch on
the back of the house of Catalina Lasa, designed by René Lalique.
I love it. #lalique #trellis

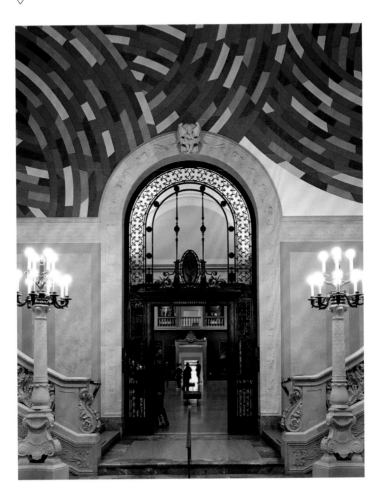

tomkligerman Who says modern and traditional can't live together?
#sollewitt #mural #color

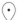 Woolworth Building, New York

10

tomkligerman Holy mosaic! This may be New York City's most beautiful lobby – you're not allowed to take photographs here – not sure how I got this. #mosaic #cassgilbert

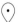

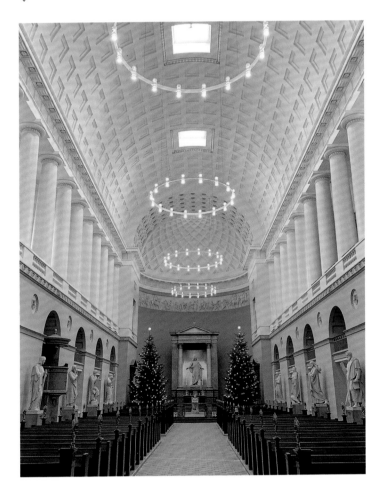

tomkligerman Christmas in Copenhagen.

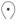
12

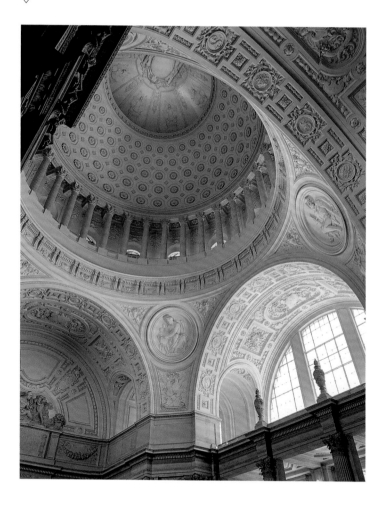

tomkligerman I can't, in my wildest dreams, imagine who has the energy and time and staff to figure out this much detail – and this is just one space of many in this spectacular City Hall. #detail

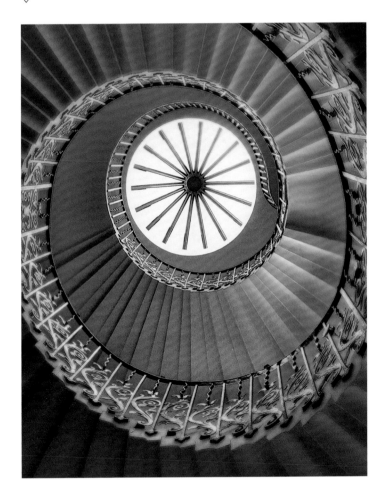

13

tomkligerman Is it OK to admit that wish I had designed this stair?
The blue paint on the railing replaces smalt, a blue coating made from
powdered, cobalt-infused blue glass. #spiralstair #skylight #inigojones

14

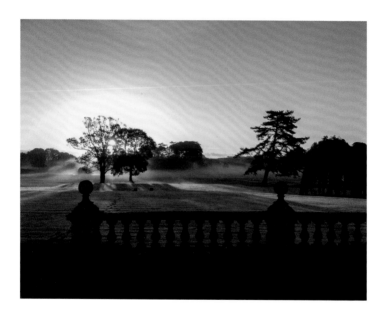

tomkligerman It's the fleeting nature of golden hour that makes it so magical. Oh … and then there's the ethereal mist and morning coolness and quiet. #mist

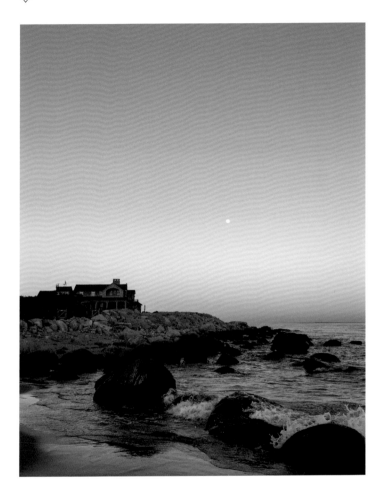

15

tomkligerman House on the rocks ... moon hung above. #rockyshore

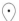

16

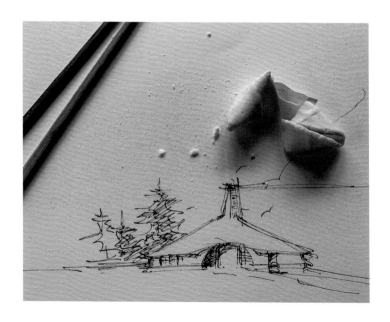

tomkligerman One day I will build this house – if not for me, then for someone. Any takers?? #napkinsketch #papertablecloth

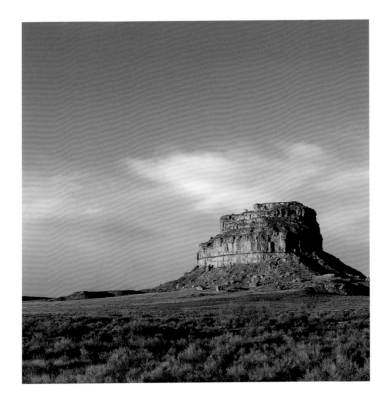

17

tomkligerman A real beaut' – Fajada Butte! Nothing like the early morning or late afternoon to bring out the colors of the desert. #butte

18

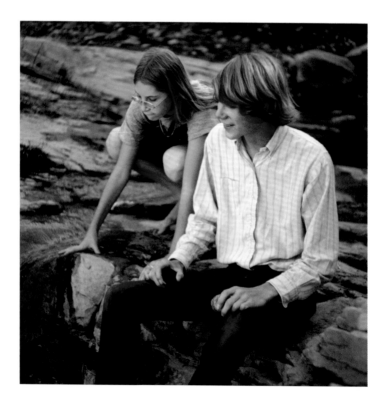

tomkligerman Teenage siblings peering over the edge of a waterfall.
#1972 Photo by John Sparks @johnsknave

Tom Kligerman

Remember this? I think it was taken in the Sandia Mountains.

Valli Kligerman

BRODDA !!!!!!!!!!

19

definitely the 70s

Valli Kligerman

the hair?

the jeans!

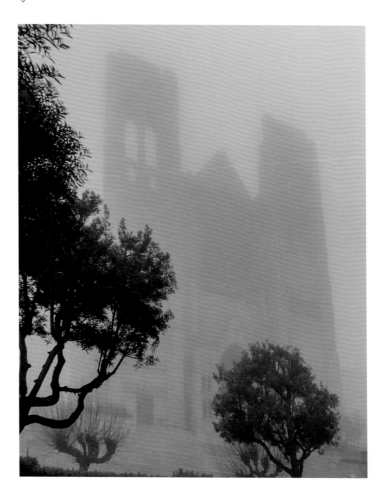

tomkligerman Ghosting atop Nob Hill – where is Quasimodo?
#cathedral

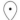

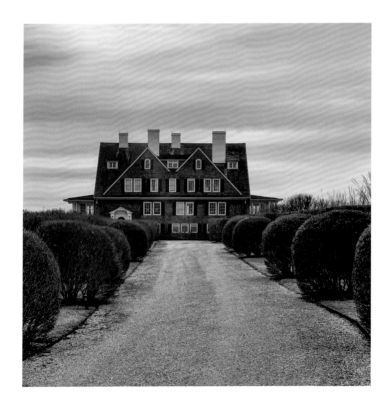

tomkligerman I can't pass this house without stopping to take a photo even if it means slowing traffic or peering over the tall gate (a benefit of being 6'-6 1/4" tall). I swallow my pride, pull over and – like a teenage girl fangirling over Harry Styles – snap a shot. An embarrassing confession … #sneakpic

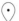
22

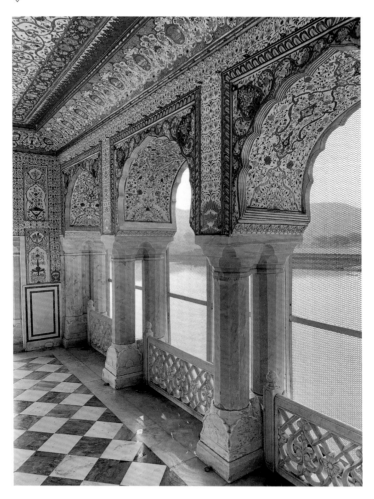

tomkligerman When too much is just right – some of the
extraordinary decorative detail at the Jal Mahal. #jalmahal

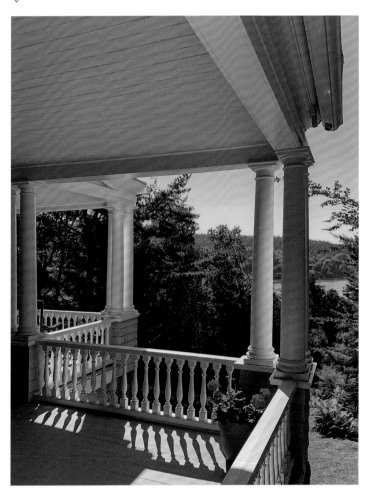

tomkligerman To wake up to this porch and this view – the air in Mt. Desert is like nowhere else. I love the blue paint on the ceiling – haint blue. #haintblue

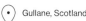

24

tomkligerman Greywalls – Edwin Lutyens' 1901 stone house near Edinburgh – it only took me 35 years to get here. Per Lennon & McCartney, you can get a tan standing in the Scottish rain … #rain

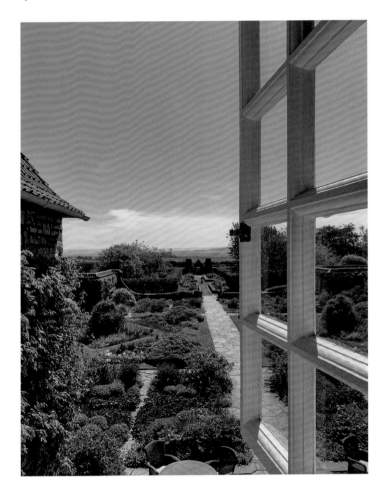

tomkligerman Why am I outside in the rain and then inside on the sunny day? #contrarian

26

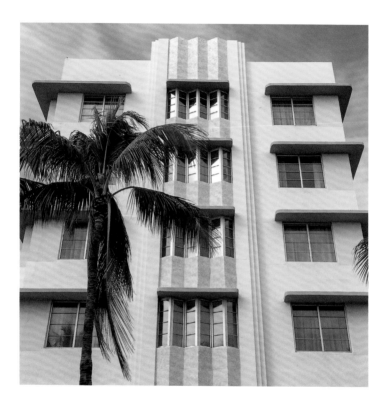

tomkligerman Deco hotel in South Beach. Exuberant pastels – is that a contradiction? #miamibeach #miamibeachdeco

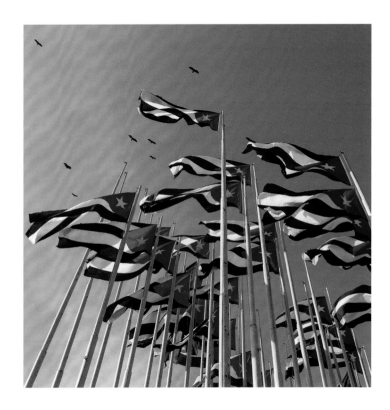

tomkligerman Cuban flags flutter from 100 flagpoles put up by Castro to block the city's view of the United States Interests Section – the birds oblivious to the Cold War tensions. #cubanflag #flagpole

28

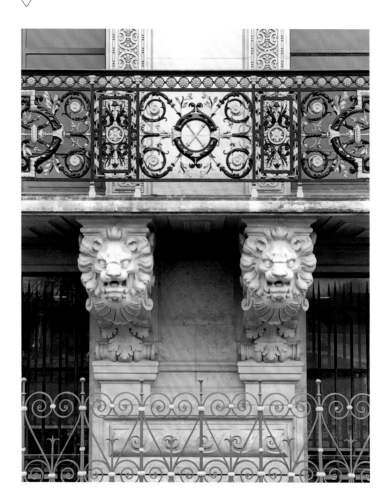

tomkligerman I would be lyin' if I said I did not like this balcony.
#balcony #lelouvre

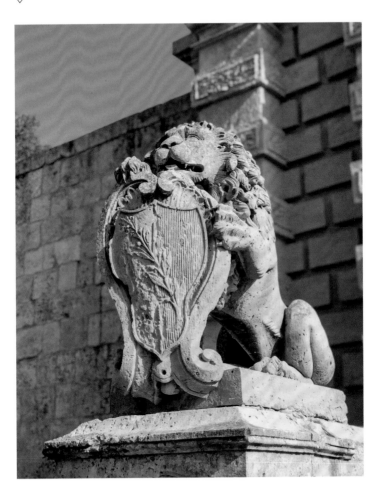

29

tomkligerman The Maltese Lion. This city (and nearly all of Malta) is built of beautiful golden limestone. #malta

The Good Old Humber

Until I was nine I thought three wheels were much safer than two. Eventually I began to outgrow a tricycle made for a four-year-old, and took off across the grass of the back yard on a tiny bicycle propelled and comforted by the fact I was much too large for the frame and very close to the ground. Then my father purchased this incredible machine, an English ten-speed road bike made by a company called Humber, more famous at that time for leather-upholstered, built-like-a-tank cars. It had an indestructible steel Reynolds 531 tube frame, and beautiful handlebars that were engraved with ribbons. A small map of the British Isles sat displayed on one side. Humber Ltd had begun in the late 19th century, and now in 1966 the bike was manifestly a product of the British Empire. It was stolen twice. Each time we got it back, and each time the police said, 'This never happens.' It was thankfully a distinctive bike.

We lived in Connecticut then, and eventually I began riding the Humber to school. Aged fourteen I was given a bicycle book and studied it from cover to cover – how to improve a bicycle, how to travel with one. I learnt it all. My father told me, 'if you would just apply this approach to your study at school, you would be a straight A student'. Over the years I changed the machine completely. Different kinds of tires, brakes and cranks from Campagnolo. I sanded off the metallic purple, trimmed with sky blue, and spray-painted it a horrible navy. It became an ugly version of its former self, but we went everywhere together. When the family moved to New Mexico the bike went with me. Together we entered onto a bigger plane of existence. On any given day I would ride 50 miles. One weekend a friend and I decided to ride our bicycles from Albuquerque, New Mexico to Springerville, Arizona; a feat accomplished with a bandage over one

eye because I had stabbed myself with a pair of needle nose pliers mere minutes before leaving.

It was four gruelling days in the desert. Tarantulas ran across the road and huge trucks thundered past our shoulders. Misjudging the distance, we drank all of our water; vultures circling us for 30 miles hoping we would drop from our saddles. The locals were equally as terrifying, shouting 'are those girls or boys?' as we rode past, referencing the shoulder-length hair we sported at that time. Parents let children risk death in those days. It is strange, given my introduction to these machines, that I still like to ride bicycles.

I never learned how to fix a car, but I could fix anything on that Humber bicycle. I saw how it was built and understood how it worked. Maybe in the end it imparted the education my father wished for me; reassembling a bicycle from parts scattered across a garage floor is somewhat akin to architecture. These days CitiBike is how I get around Manhattan. I like the pace. Throughout the Covid pandemic I could hear birdsong.

I kept the Humber for 40 years. Then in 2006 I purchased a new bike. It was carbon fiber, not steel. Everything had changed; it was lighter, easier to ride, went faster – how was it that I had persisted with that relic? Then that carbon fiber machine was replaced by a new, custom-made, titanium bicycle. This time with electronic gears and disc-brakes that are operated by a fluid. Bikes had become like cars; beyond normal human, and my own, comprehension.

When the time came that I no longer needed the Humber I agonised over the loss of my old friend. At least at first. I realized it could still have a life if I donated it, like a kidney, to a better cause. I said goodbye and contributed it to a charity whose mission is to send old bicycles to countries where people can use the parts to make things they need. When I was in India I thought to myself perhaps the wheels of my bicycle would pass me by attached to a cart. Reincarnation?

31

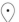

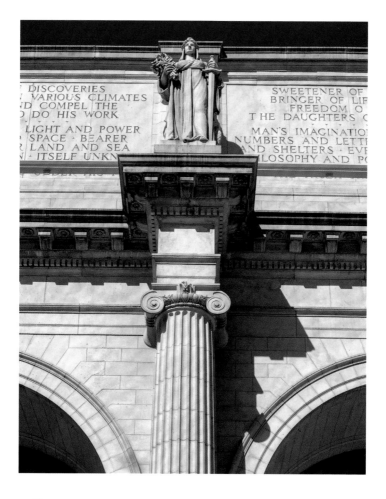

tomkligerman They don't build 'em like they used to. This station
is beautiful – Penn Station, New York, not so much. #unionstation

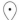

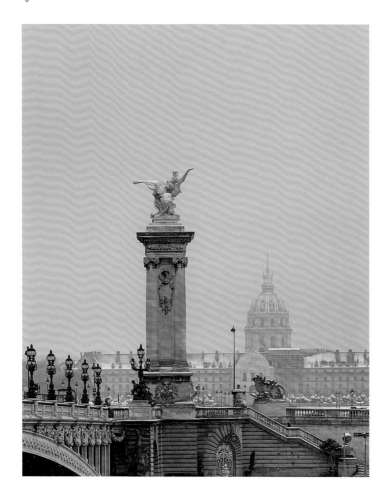

tomkligerman Le Pont Alexandre III – too much ain't enough.
A nice way for the French to honor their Russian friends.
#pontalexandreIII #snow

34

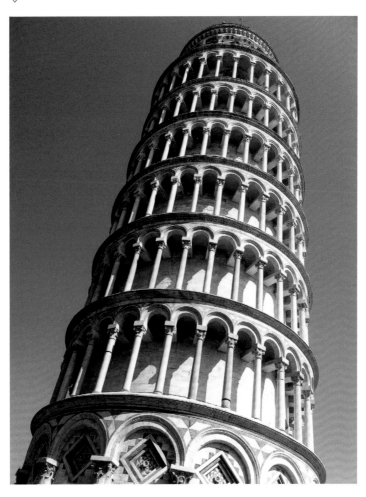

tomkligerman The last time I was here I was 16 years old and you could walk to the top. Insane! There are no railings and the whole building tilts – scared the hell out of me. #pisa #leaningtowerofpisa

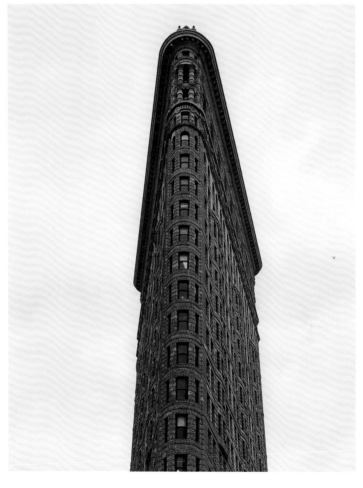

tomkligerman The Flatiron Building masquerading as a skinny round tower. #flatiron #danielburnham

 British Embassy, Washington, D.C.

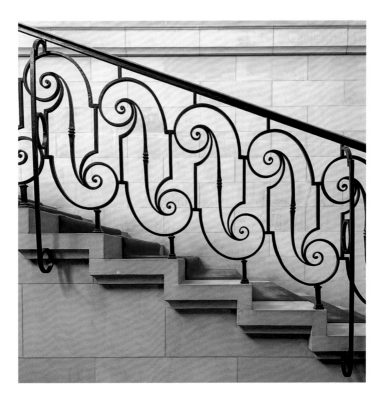

tomkligerman Lutyens here …

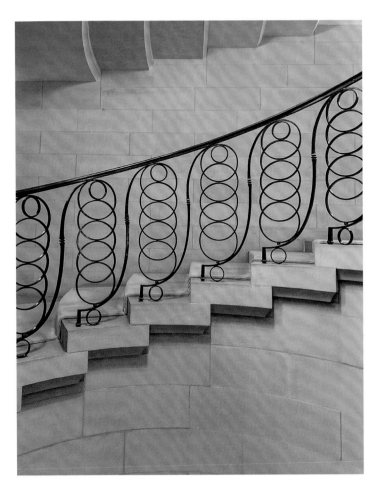

tomkligerman ... and Lutyens there.

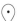

38

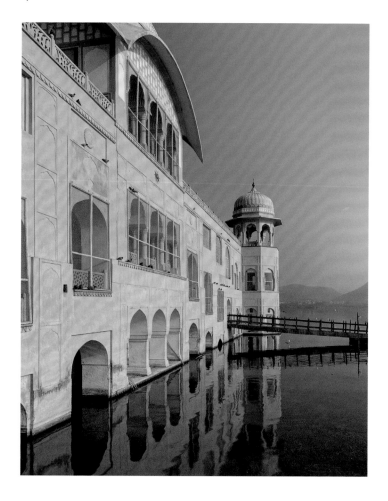

tomkligerman Early morning on Man Sagar Lake. Arrival at this floating palace – really an elaborate duck blind. Although it looks gigantic, it is built around an enormous rock island. Hence the rooms are only corridors around the perimeter of the stone outcroop. The roof is a beautiful raised garden with Mughal pavilions. #jalmahal #jaipur

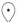
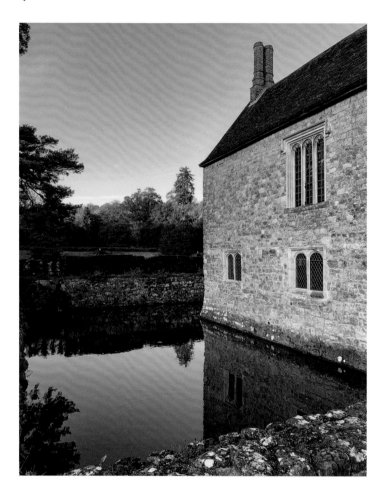

tomkligerman A memorable Kentish morning – a lucky find.
I want to live in this divine medieval manor house. #ighthammote
#moat #romance

40

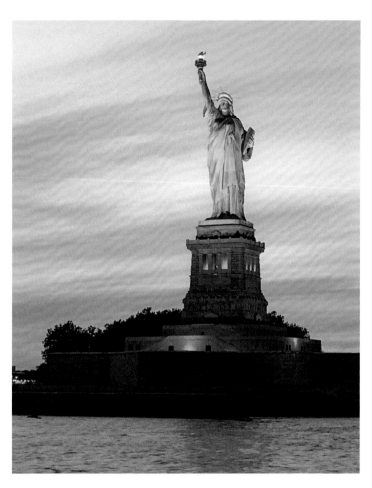

tomkligerman Hard not to be moved by this sight of Liberty high above the harbor – this photo was taken from a friend's boat on September 11th. #ladyliberty #statueofliberty

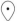 Hell Gate Bridge, New York City

tomkligerman I whipped out my iPhone just in time to take this photograph from a speeding train. Most people forget (or don't know) that New York City is 50% water. The rivers, bays and estuaries around the city are equal in area to the city itself – over 200,000 acres each. By the way, I refuse to call this bridge anything other than the Triboro. #curmudgeon

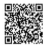

42

"Don't just draw the plan, live the plan"

Tom Kligerman

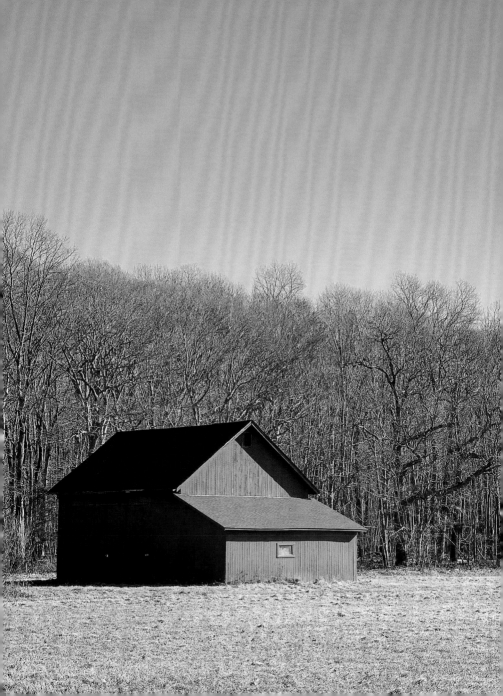

44

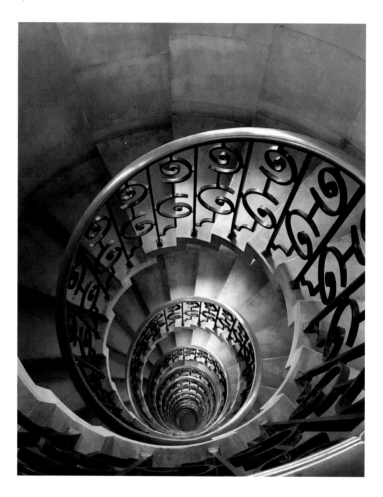

tomkligerman Lusting after a Lutyens stair – and not for the first time.
Sir Edwin was a master of geometry in every material: here stone and
steel – and a little brass. #stair #metalrailing #spiralstair

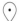 Stonington, Connecticut

tomkligerman Stonington's sunset and sailboats – view from a favorite waterside bar. #goldenhour

46

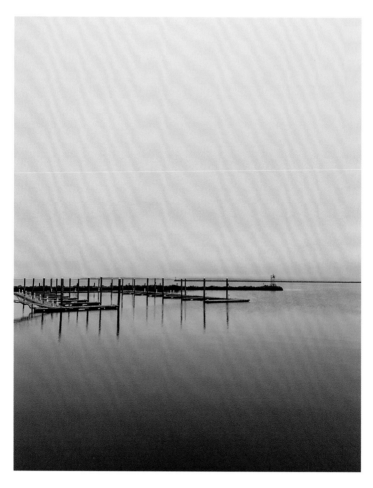

tomkligerman It's amazing what a couple of months can do – empty docks and slips in Stonington, once crowded with boats, Connecticut. Graphic beauty – a wood and water haiku. #emptyslips #winterscene

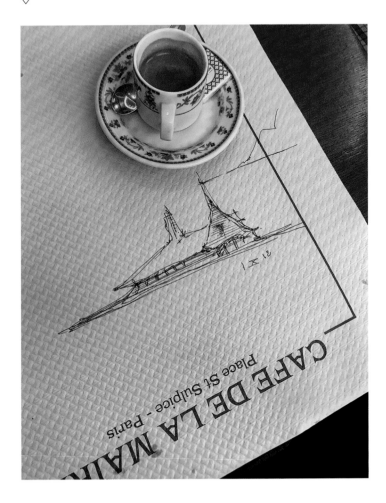

tomkligerman Café at a … café. Even in Paris I get the shingles.
#shinglestylehouse

48

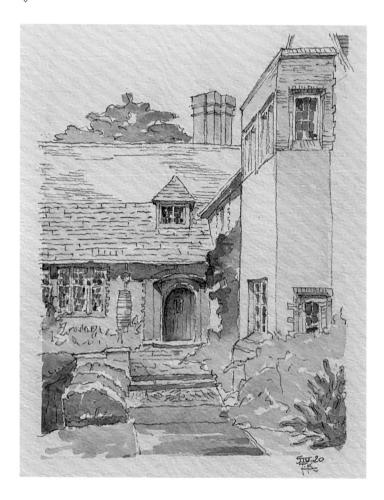

tomkligerman Goddards – Edwin Lutyens, architect. Built 1898-1900 and enlarged in 1910. My watercolor of the courtyard. Mostly a pencil sketch with a little color to emphasize the forms. #pencilsketch

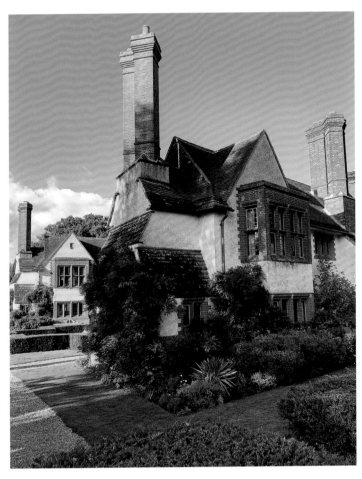

tomkligerman The actual house. I was amazed when I arrived at how rich the colors were – the stucco is so golden. The whole house has a rich arts and crafts palette: brick and tile, leaded glass, painted and raw oak woodwork. It was a dream to live in this house for a week. #surrey #englishartsandcrafts

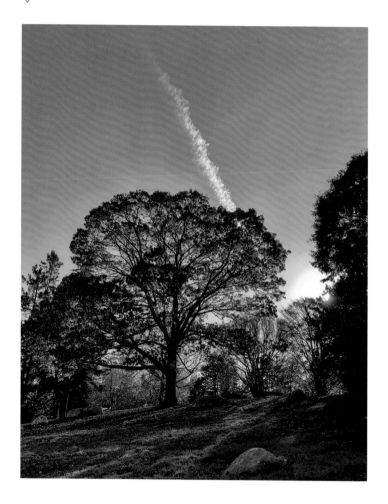

tomkligerman Tree. Afternoon in November. #contrail

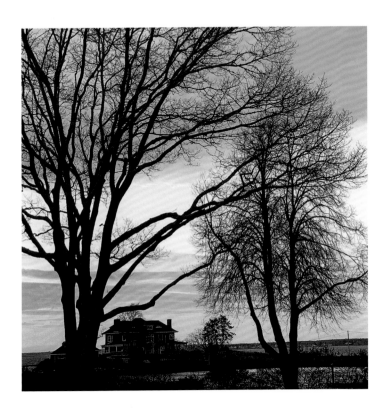

tomkligerman Another tree. Evening in December. #lastlight

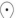

52

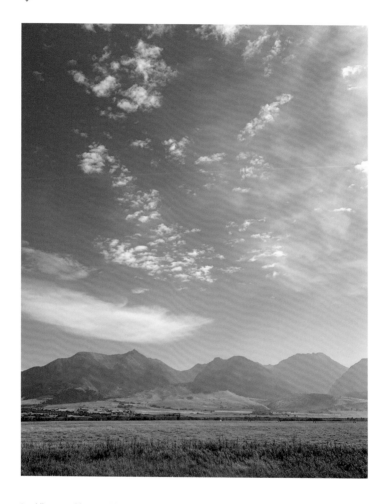

tomkligerman Montana, big sky. Or was it Big Sky, Montana?
#americanwest

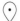
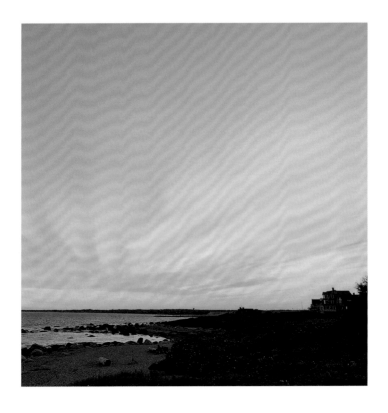

53

tomkligerman Sea Glass Beach – pebbly sand and glass treasures.
#beach #rockyshore

Two Queens
and a Camera

About a year after my first, terrifying exposure to sailing in a boat skippered by my father – more on this later – I made another venture onto the water. My father was an oncologist and had obtained a year's placement doing cancer research in one of the London hospitals, and the family went with him. We took our car – the one thing about me that impressed my English classmates who otherwise hated having an American child in their midst – and some steamer trunks, and made the crossing on board the Cunard liner Queen Elizabeth. When we got to the terminal on the pier, all I could see was the side of the ship and porthole after porthole after porthole. The stevedore warned me not to get lost, but my friend Dana and I were soon running all over the ship. When the announcement was made that visitors should leave the ship, we dashed hither and thither with no idea where our parents were to be found. We must have caught up with them eventually because Dana made it safely ashore, and then I had no one my own age to play with except for my sister.

Nothing much happened during that crossing, but I never felt bored. I loved waking up and seeing the water moving by, and then, periodically, a school of flying fish who can use their fins to take off and then glide for hundreds of yards. Every time of day had its particular magic, even if it seemed suspended in a kind of stasis, and the mornings and the evenings were spectacular. The light changes before your eyes, the sea goes from purple to royal blue. In my ignorance I thought the drawing room was the place that you went to draw. And so I sat there, under the eyes of old English gentlemen smoking cigars, with my pad of paper, drawing horses. On the way home, aboard the Queen Mary, we were eating dinner in the obligatory coat and tie when suddenly the ship listed to port. The plates

and cutlery slid over the lip that was there to restrain them and crashed to the floor. We all had to stagger back to our cabins. The sea appeared to be at forty-five degrees angle to the porthole. Then we listed the other way. I thought it was thrilling, my mother and sister less so. The captain had realized there was a fishing fleet ahead and the huge liner suddenly had to weave a figure eight to avoid it.

There was, of course, no Instagram in those days. I had only my Kodak Brownie camera. The pictures were exposed on a roll of film, twelve pictures to the roll. You could not see what you had taken until a week and a half later when they were developed, only to discover that they were atrocious — out of focus, grey, smeary. There was not much you could do to manipulate the images once they were taken. What was on the film was what you saw on the print. It made you think long and hard before pressing the button. Now there are times when I'll take eight versions of the same subject. I have over 50,000 photographs on my iPhone alone, and more on my computer from previous phones. Ready-aim-shoot has become ready-shoot-change. I wish I'd had an iPhone on the Queen Mary.

56

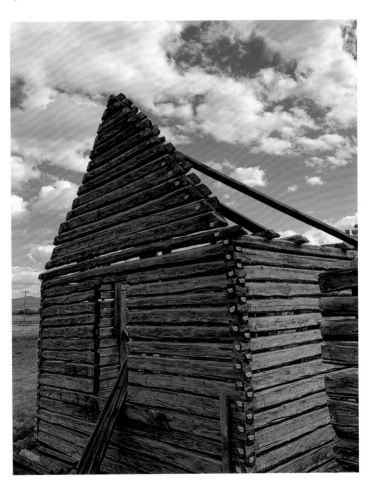

tomkligerman Weathered log structure awaiting a new family.
Imagine the frontiersmen hand-chopping those logs and laboriously
stacking them. #frontierhome.

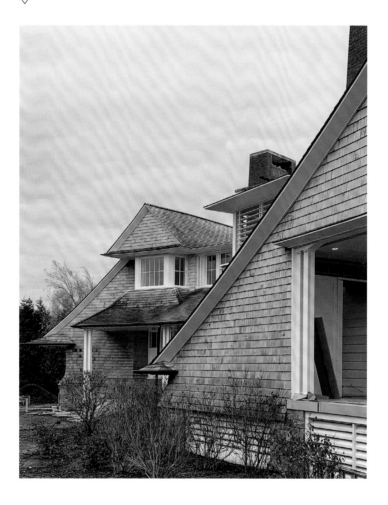

tomkligerman I love to curve the buildings I design. Curved rooflines echo one another at this shingled cottage. #thenewshingledhouse

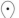

58

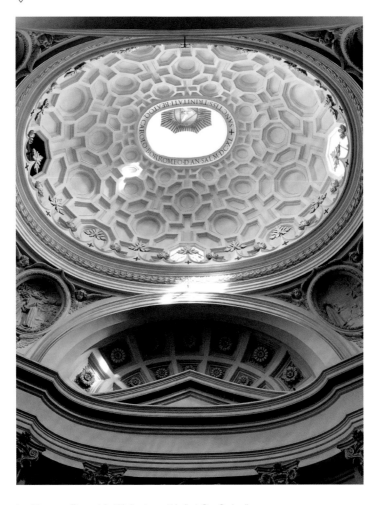

tomkligerman Borromini at his best – and his first. San Carlo alle
Quattro Fontane, aka San Carlino. A building I never go by without
going in. #homage #dome #rome

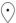 Vedado, Havana, Cuba

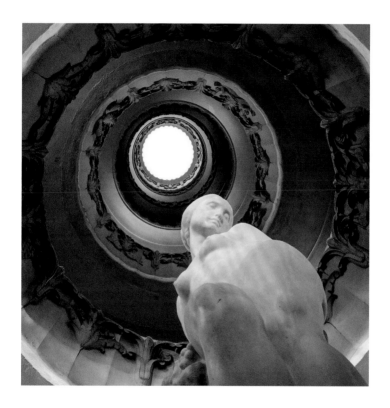

tomkligerman A kindly gaze – this is a city of great architectural gems
and no lack of imagination. #lookup #cuba

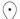

60

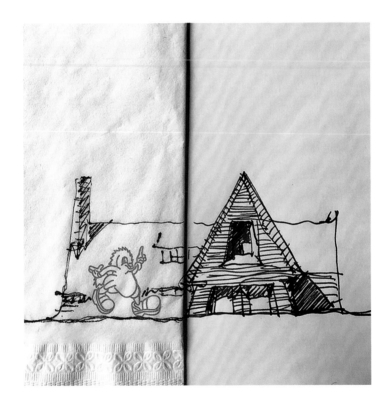

tomkligerman Taxi!

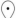

tomkligerman The duck of Robert Venturi fame. "Is this building a duck or a decorated shed?", I ask my architect friends – or any friend for that matter. This duck started life as an egg stand. #duck #robertventuri

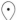
62

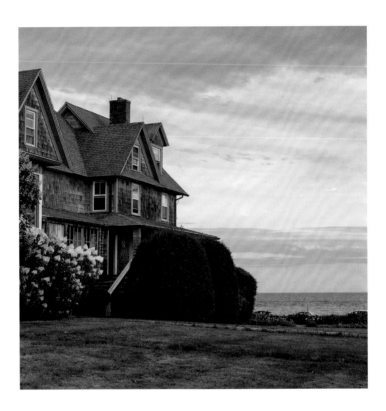

tomkligerman A shingle cottage I have known since I was 10 – have
never been inside … If the owner is reading this, please drop me a line.
#atlanticocean #newengland

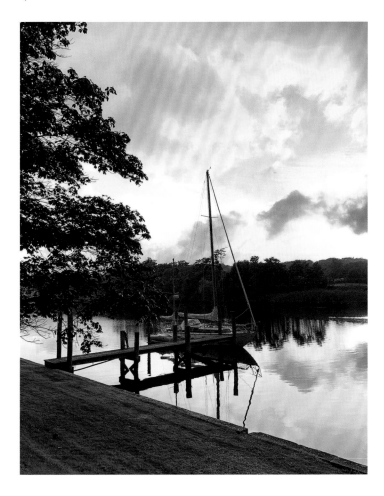

tomkligerman I have ridden my bicycle past this sailboat at least 200 times. I stop to take a photograph one out of every ten times. A friend who rides with me repaired this boat back when he was 18 years old. It has a long history in this area. #oldschool #reflection

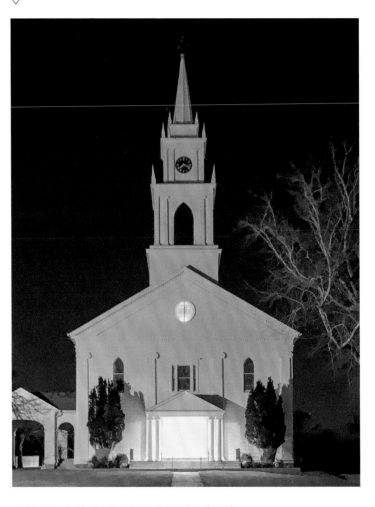

tomkligerman Is this church real or made out of cardboard?
#cardboard #bridgehampton

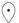
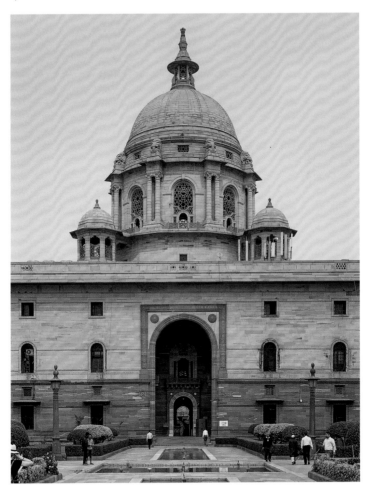

tomkligerman Gold and red sandstone on architect Herbert Baker's Secretariat Building.

66

tomkligerman A get well card to a fellow first grader.
#crayondrawing #firstgrade

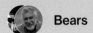 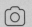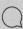
Tom Kligerman

 First. Grade – bears, not buildings

John Anderson

 we've all got to start somewhere...

 #crayondrawing #firstgrade

John Anderson

 with me, early on I started creating things out of foil, chewing gum wrappers, and here we both are today...

 all has paid off

68

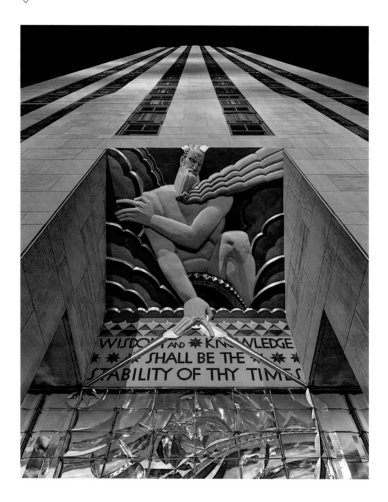

tomkligerman As if this building wasn't cool enough they had to bathe it in purple – my favorite color. This figure is a Deco nod to William Blake's *The Ancient of Days*. Great source, great interpretation. I like them both.

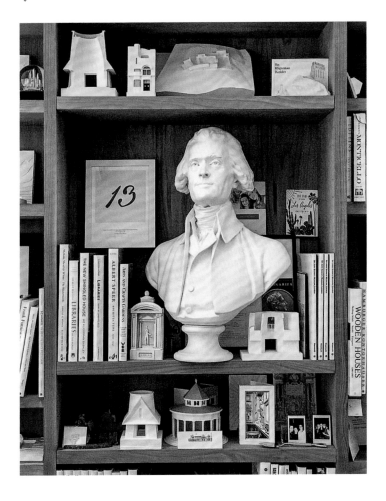

tomkligerman My roommate, Tom (Jefferson). Surrounded by all kinds of study models, invitations, books and photographs. My own personal Sir John Soane's Museum. #sirjohnsoanesmuseum

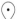

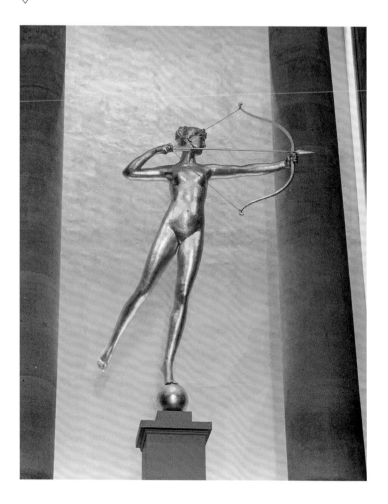

70

tomkligerman Diana – this golden girl shocked and titillated New York City 130 years ago. Sculptor Augustus Saint-Gaudens' figure stood atop the now demolished Madison Square Gardens. I've always been fascinated by her and the time she represents – my favorite period in the history of NYC. #lostnewyork

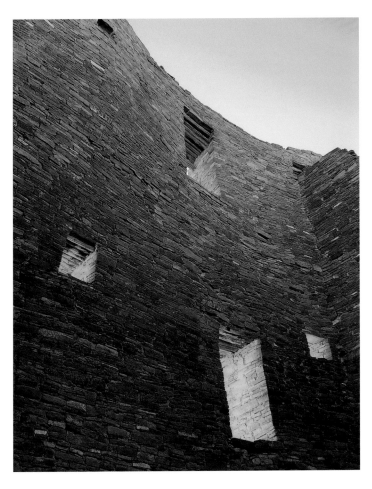

tomkligerman Pueblo Bonito in the early morning's quiet, glancing
sunlight. I find these ruins so powerful – architecture as sculpture.
#ruins #chacocanyon

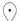
72

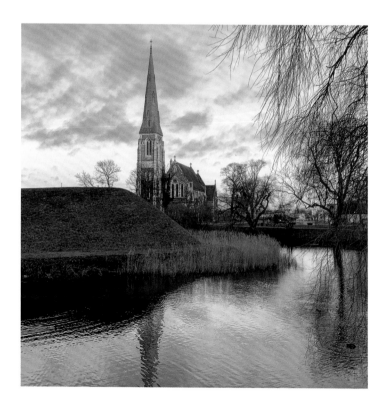

tomkligerman St. Alban's Anglican Church reflecting in the canal around Copenhagen's Kastellet on a warm Christmas afternoon. #copenhagen #kastellet #denmark

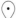

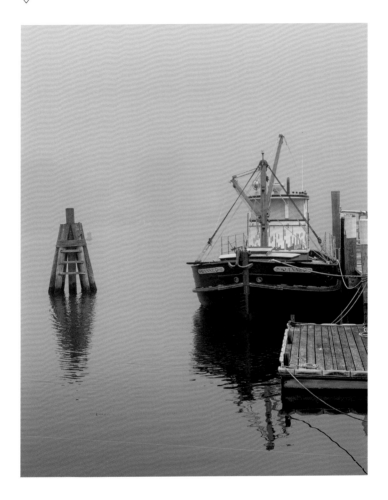

tomkligerman Reflection: gray morning #homeport

74

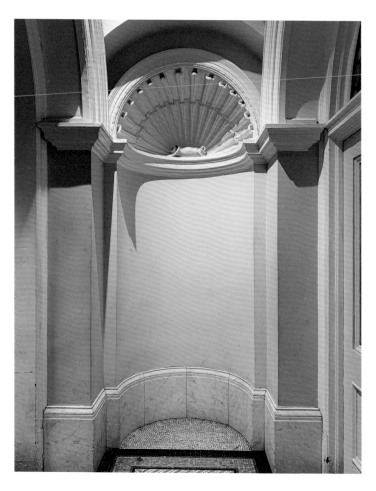

tomkligerman I love finding Roman moments in New York City.
Saturday morning figure drawing at the Art Students League.
#artstudentsleague #figuredrawing

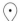
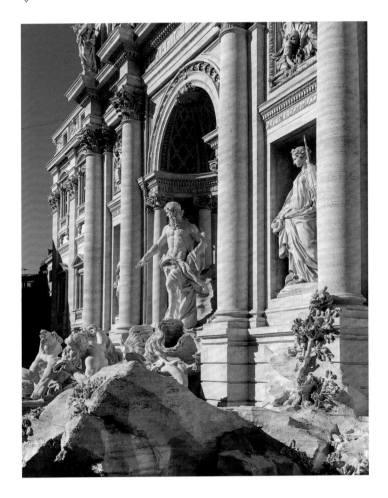

tomkligerman And I love finding Roman moments in Rome.
Saturday morning while I was at the American Academy in Rome.
#trevifountain #fountain

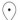
76

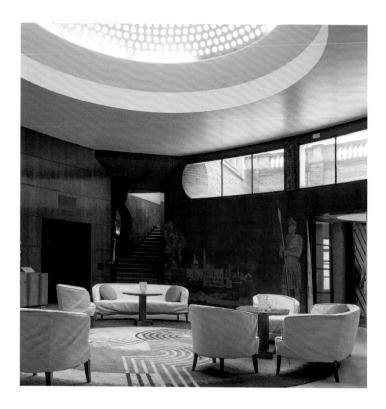

tomkligerman Streamlined Deco London – an English rarity. Amazingly, this room in Eltham Palace is attached to a building with Gothic roots, much of which remains. #elthampalace

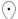 Jama Masjid, Chandi Chowk, Delhi, India

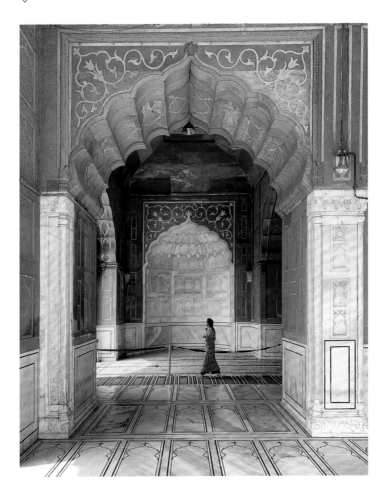

tomkligerman A stroller by in the mosque – I never tire of the red sandstone and white marble of Mughal India #mughalarchitecture #olddelhi #mosque

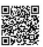

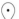

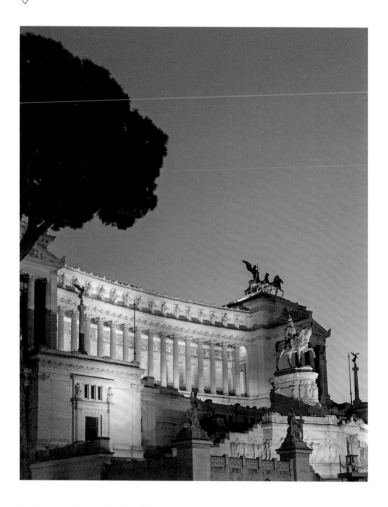

tomkligerman Roman gloaming. #piazzavenezia

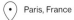
Paris, France

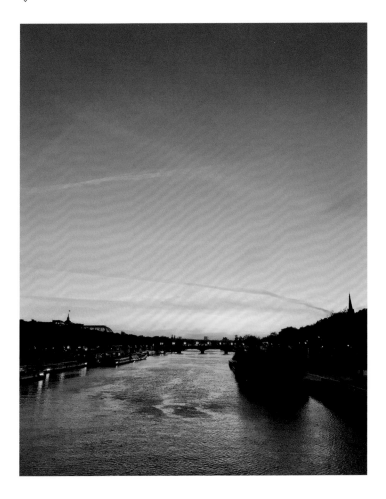

79

tomkligerman Everything being the Seine, I'll take Paris. #paris #sunrise

Beetle Cats
I Have Known

I love the ocean. I love the smell of the ocean, I love being on the sea, I love boats. Every time I cast off the sound of the water lapping against a wooden hull mixes with the smell of the varnish and the salt air in the breeze to make a cocktail that, as real alcoholic cocktails do, puts me instantly in a relaxed state. Boat building requires supreme craftsmanship. Architecture pales in comparison to the skills needed to lay out the lines, curve all those planks, to cut everything to exactly the right shape, size, and form. My uncle was a traditional wooden boat builder. By hand and eye alone he could cut a plank of wood, an inch wide and six inches high, into two pieces of wedge-shaped board, each of them eight feet in length and half an inch thick. Boats are so beautiful, always changing depending on the angle you see them from. It's this magnificent fact that inspired me to introduce curves into my buildings.

I was five when my father rented a little Sunfish, more a surfboard with a sail on it than a boat. We were summering on Martha's Vineyard in a little Tudor style cottage, and at that age the Sunfish was terrifying. It rode so low in the water, and we felt so far from the shore. Ocean water would lap over the side of the boat as it heeled. Despite my orange cotton life preserver I thought I was going to die. Yet it stuck with me, this idea of gliding across the water in absolute silence. Later we started to spend summers in Weekapaug – a native Pequot name meaning 'at the end of the pond' – in Rhode Island. The pond in question is actually a tidal saltwater lake, on which I learned to sail. I started racing Beetle Cats, which is an oxymoron as the fastest they can go is at most a jogging pace due to their weight and shape. But when everybody's going 4 knots, it can be very exciting.

Eventually I bought my own Beetle Cat. It was old and battered, but I sanded it down, caulked it, painted it, and called it Spar. That was a twelve-year-old's pun on masts and sparring — it showed my competitive instinct. I had a dinghy as well that I called Sparkle, which I rowed out to get to the moored boat. Spar and Sparkle were both yellow. My second Beetle was much more sophisticated and painted Endeavour Blue, the color used on a J-Class boat called Endeavour for an America's Cup defense in the 1930s. I called the current owner of Endeavour to get the formula for the paint because you can't just buy it. Cans of paint that say Endeavour Blue don't get it right. I sailed in regattas with this boat, and have numerous trophies as evidence.

The first time I walked into the New York Yacht Club, that incredible building on West 44th Street with windows designed like the stern of a galleon, I was thrown out. I wasn't a member. But it so happened that my first client, when I launched myself as an architect, belonged to the Club. I told him I would design his apartment for free if he got me in. I was more interested in getting into the Yacht Club than eating. The deal worked, and I did become a member. But my own boat was never a J-Class: I have always remained loyal to my strangely ungainly but intoxicating first love, the Beetle Cat.

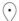
82

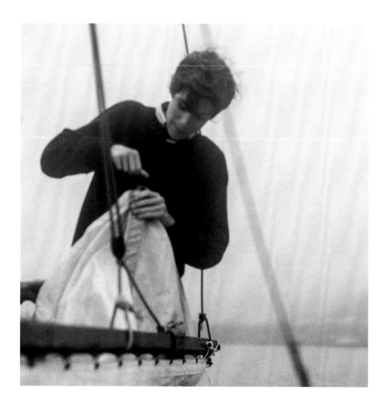

tomkligerman Derigging Spar as a twelve-year-old, unaware my fisherman sweater was on inside out and backwards. Ah, for those simpler days aboard Spar. #rigging #catboat #1969 Photo by Roger Wilcox @rbcwilcox

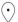
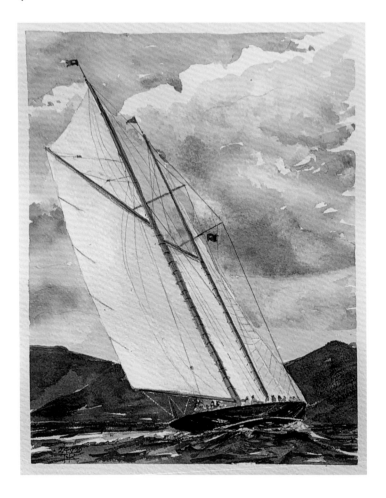

tomkligerman Whisky Watercolor Club — a schooner off the coast of Antigua from a photo by a great boat photographer @markkrasnowphotography. Locked up during Covid, painting is a chance to learn a new skill and dream of exotic places in exotic ways. #schooner

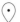

84

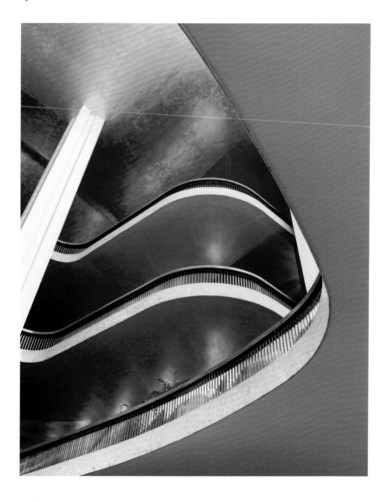

tomkligerman The lyrical flow of balconies at the Metropolitan Opera House – long before this building was completed in 1966 someone described architecture as frozen music. Maybe he saw this building in a dream. #opera.

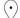

85

tomkligerman Upturned Beetle Cats awaiting a good bottom
scrubbing...! #woodenboat

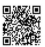

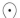
86

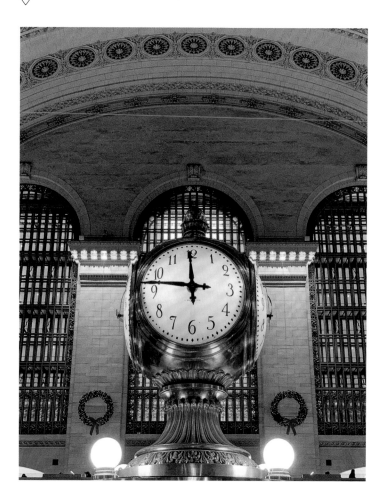

tomkligerman Meet me at the …

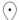

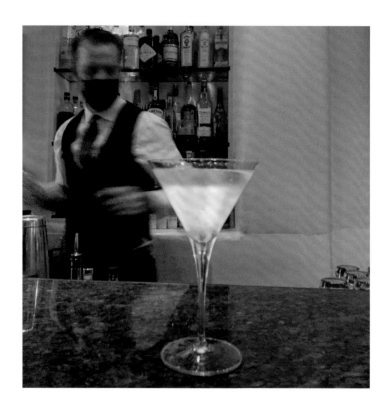

tomkligerman Martini spoken here at my favorite bar anywhere.
#martini

88

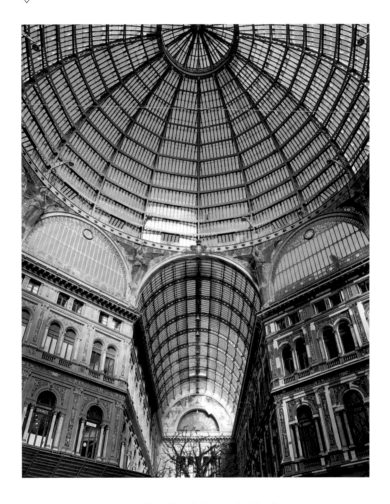

tomkligerman Naples – or, as the Neopolitans insist on saying, Napoli. They hate the idea that someone might think you are talking about Florida. The beautiful Galleria – I like this one more than the one in Milan. #napoli #galleria

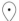 Place du Pantheon, Paris, France

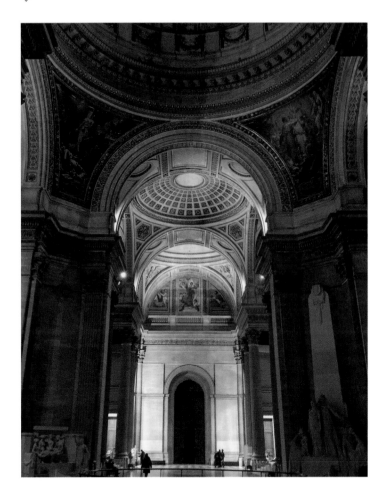

tomkligerman One of my favorite parts of Paris is La Place Sainte-Geneviève, just outside this building. Outstanding edifices surround the square, one of them being the Pantheon, its interior shown here. Grand enough? #leftbank

90

tomkligerman The ramparts below the Dome of the Rock #jerusalem #domeoftherock

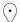

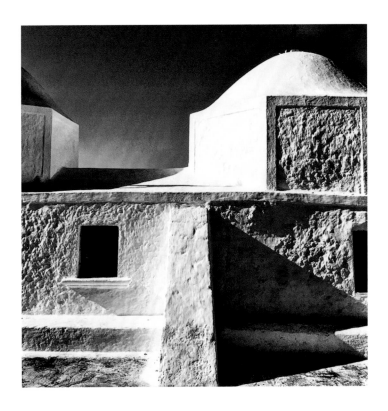

tomkligerman Sometimes black and white tells a better story – sun baked moment in Greece. #greece #aegean

"The ceiling is the most important part of a room"

Tom Kligerman

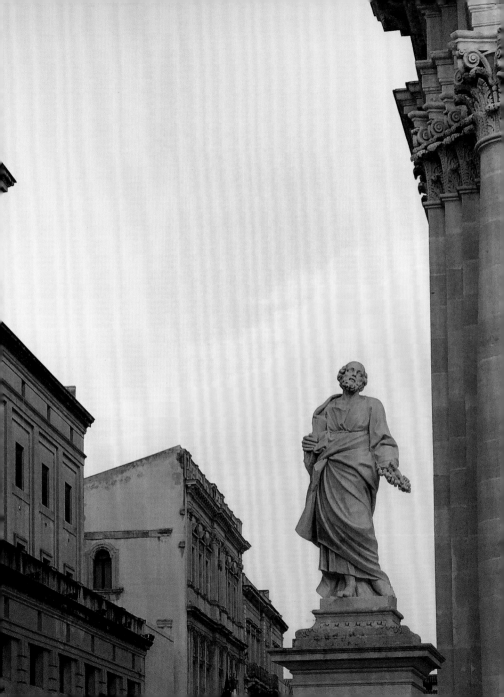

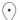

94

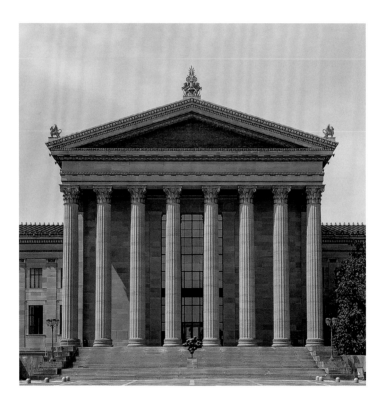

tomkligerman I love the golden stone used on this magnificent structure that sits high above the Schuylkill River. Even though the building is in Pennsylvania it is clad in limestone from Minnesota. Knowing this kind of thing makes a building even more interesting. I guess it's what they mean when you say an architect can "read" a building. #museum #philadelphia

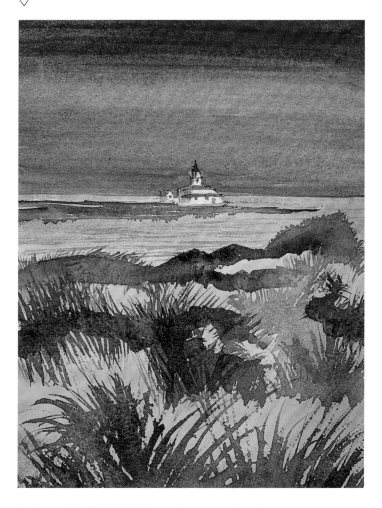

tomkligerman The Watch Hill Light across the water; I went hog wild on the dune grass is in the foreground … #dunegrass #lighthouse

96

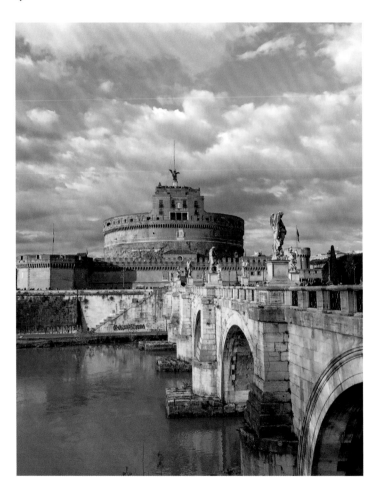

tomkligerman Ponte Sant'Angelo with the Castel Sant'Angelo – part of my evening constitutional while living in Rome at the American Academy. #pontesantangelo #tiberriver

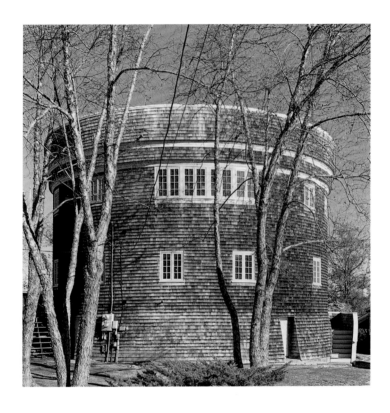

tomkligerman Charles McKim is the reason that the American Academy exists – it was his dream and he worked on it tirelessly for many years, leaning on his rich clients like J. P. Morgan and others to fund the institution. Lo and behold – a house on Jamestown island in Rhode Island. It simply must be based on his time in Rome. The best copy, then riff. #roundhouse

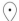
98

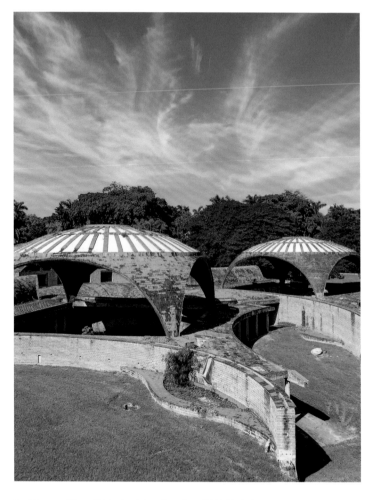

tomkligerman The unfinished and decaying ruins of Fidel Castro's vision for a new architecture. Architect Vittorio Garatti was tapped to design the School of Ballet. The campus was built on the grounds of a former golf course, an idea hatched when Castro and Che Guevara were there playing a round. #fidelcastro #balletschool

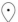

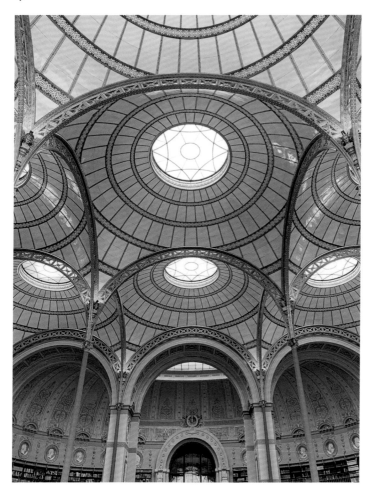

tomkligerman Parachute domes – Henri Labrouste, architect. Maybe my favorite room in the world? It is hard to tell whether those skinny cast iron columns are supporting the weight of those domes or if they're tethering them from floating away … #henrilabrouste #library #parachutedome

100

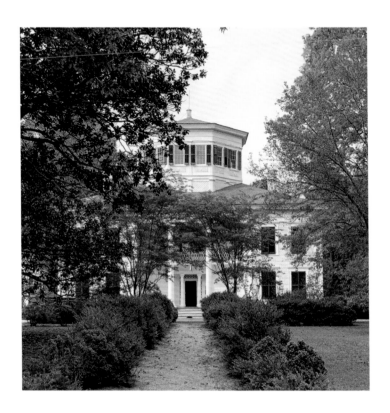

tomkligerman Waverly Plantation – on my route down the Mississippi during my 2019 sabbatical in the Deep South. #mississippi

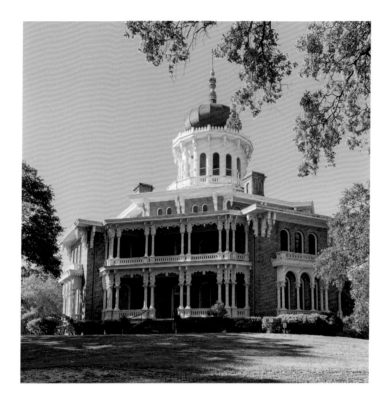

tomkligerman I think this is the biggest octagonal house in the United States – one of many beautiful houses in Natchez. Except for a few rooms on the 1st floor the entire inside of this house was never completed and is a giant bird nest of timber framing three storeys high. #cupola #natchez

102

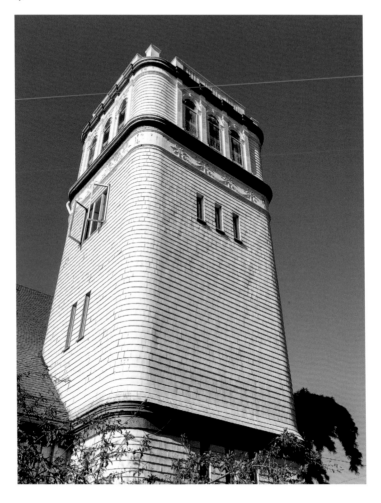

tomkligerman Steam bent shingle wrapped tower – former church,
present day home. #churchtower

 S. C. Johnson Wax Headquarters, Racine, Wisconsin

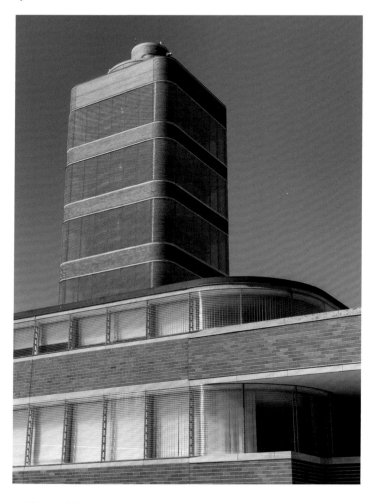

tomkligerman Brick, stone and glass rod wrapped tower: the genius of Mr. Wright. #johnsonwax #franklloydwright

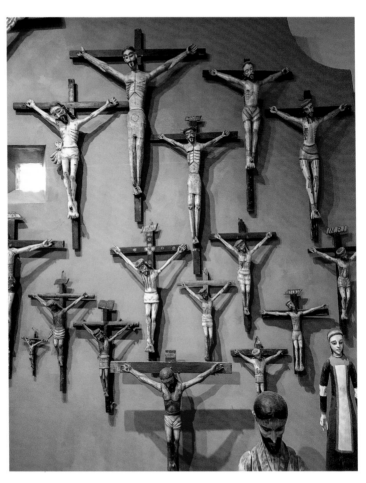

tomkligerman What would Santa Fe be without a few Cristos?
#crucifix #newmexico

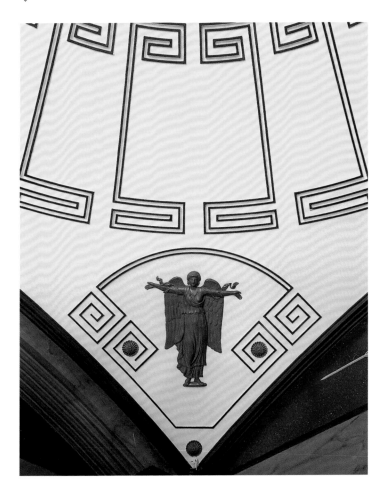

tomkligerman Sir John Soane's Breakfast Room at Pitzhanger Manor – a lovely little moment that combines Greek meanders and a happy little figure bidding good morning! #johnsoane

She's Peppy

The first car I bought was a black 1968 Dodge Charger R/T with a 440 cubic engine in it. It is the car that the bad guys drive during the famous chase scene in the movie Bullitt, but in my case with white flames painted on the side. When I took it for a test drive the huge V8 engine, seven litres, made me feel as if someone had ignited a rocket on my back. It cost $650, a lot for me at the time, but I had to buy it. My mother was away and my father thought he had better look the car over. A blast of sound erupted when he turned on the engine, and as he drove off a shower of gravel from the driveway pelted the front of our house. The dream had to be over, I would never get this car. But instead he said, almost cluelessly, 'she's peppy!'. I bought it, and when my mother returned days later I heard this terrible argument coming from their bedroom: 'you let him buy a hot rod?!'

In the end everybody loved the Charger because it was so incredibly fast. My father would drive it to his office in the University of New Mexico, where he was the Director of the Cancer Research Center, and park it in the spot for the Director. One day he came out of work and it had been towed – the police assumed a car like that should not have been there, and had to return it from the pound at their own expense. Even my mother drove the car sometimes, burning off teenagers at the lights.

I originally thought I would design cars. I drew them all the time and would occasionally find that, years later, big companies like Pontiac would produce builds similar to my ideas. At the age of eleven I wrote to Rolls-Royce suggesting they put together a two-seater convertible sports car to compete with the Mercedes 280 SL (they missed a trick; I did not get a response). But after reading about industrial design I realized how

difficult it is to succeed as a car designer. That world is as competitive as Hollywood. If I was lucky, I would design the bezel around a headlight. If I got a really good job, I might work on a door handle. I chose instead to apply to architecture school – but my love of cars still persists.

If I had the means to, I would have a collection of at least 500 cars. When I can't sleep at night I make lists of the cars I would like to have: cars from the United States in the 1950s and 1960s, French cars from the 1970s.

Now I have a Tesla which goes from 0-60 in under four seconds: you feel as though you've been knocked off your feet. When you floored the Charger, you could hear it 700 miles away – it was great. The Tesla is faster – and silent – something I've come to love.

The best cars have the most beautiful, streamlined shapes. There is also a beauty to the mechanics even if, like me, you do not fully understand the engineering. Cars are functional art, which makes them like architecture. I love car cities, like London, where you see incredible models parked on the street. I see it as a legacy of the days of the horse and carriage because the English loved horses so much. Los Angeles depends on cars, and the sunny climate is ideal for showing them off (and keeping them rust free). Detroit, with its manufacturing history, is a city of classic cars you only see in books. My home is New York: not a car city but I can dream.

108

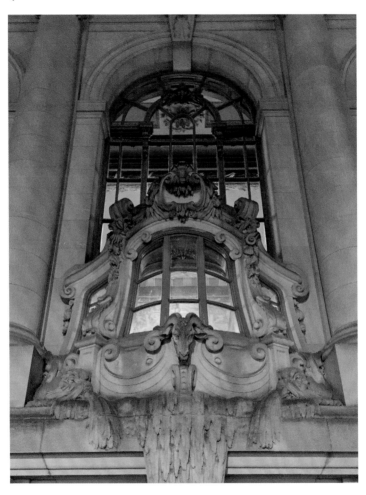

tomkligerman Bay windows masquerading as Dutch sailing ships –
these are the best windows in all of New York City. #newyorkyachtclub

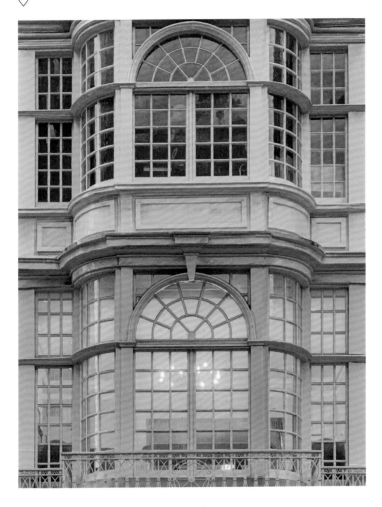

tomkligerman No they aren't, these are. #baywindow

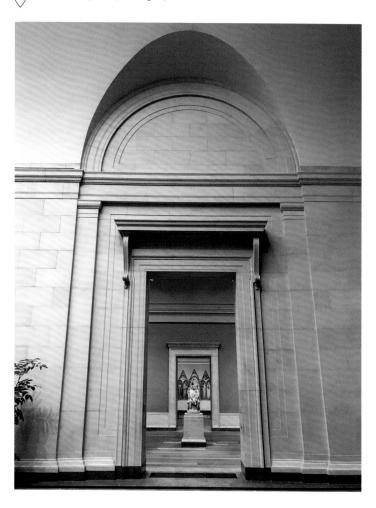

National Gallery of Art, Washington, DC

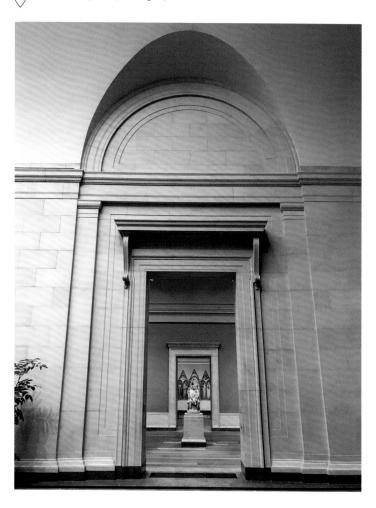

tomkligerman The best classical building in the United States –
architect John Russell Pope's art museum on the Mall. #artmuseum

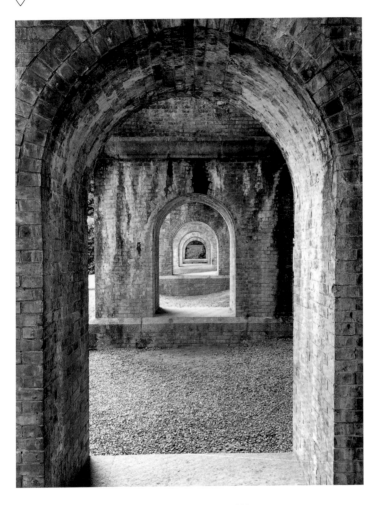

tomkligerman Under the Suirokau – an aqueduct from the 1890s.
I love that the Japanese call it a "water bridge". #aquaduct

112

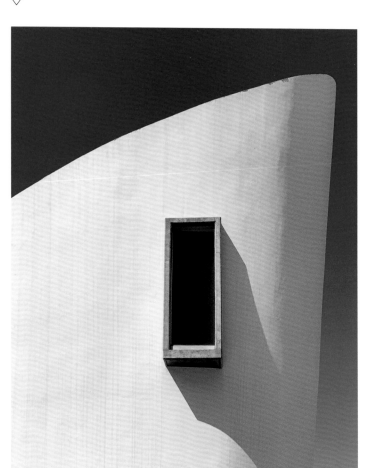

tomkligerman A modern building sets sail in central Tel Aviv. #israel

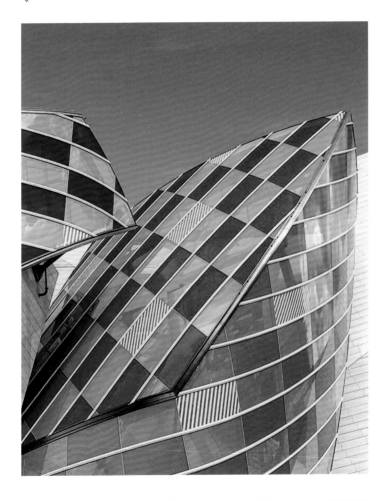

113

tomkligerman Frank Gehry's museum all done up in colors by artist Daniel Buren – a giant scale heraldry in Paris' Bois de Boulogne. #modernarchitecture

114

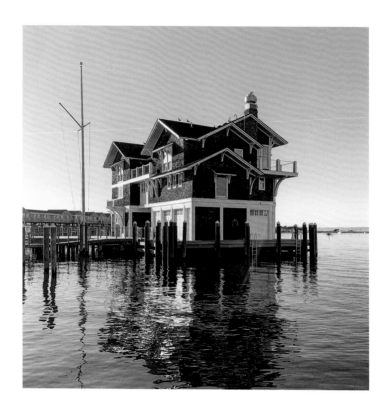

tomkligerman The Watch Hill Yacht Club – a floating homage to all things sailing. #sailboat #rhodeisland

 Kinkaku-ji (Golden Pavilion), Kyoto, Japan

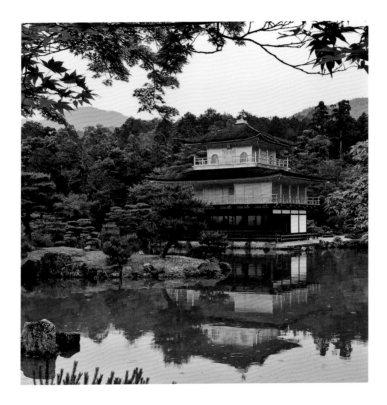

tomkligerman Beautiful mirage. #kyoto #goldenpavilion #japan

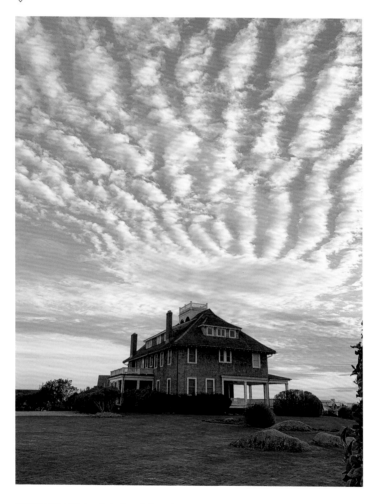

tomkligerman Mackerel sky #porch #evening

117

tomkligerman The ceiling in a new house in the Hamptons. Grateful for
good contractors – and computer guided saws. #coveredporch

118

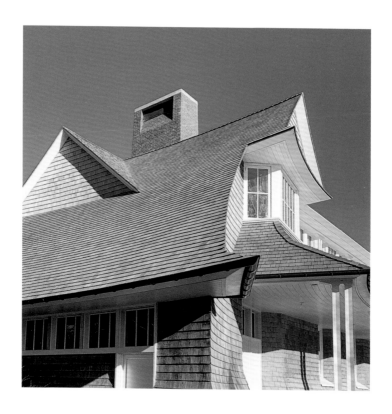

tomkligerman Shingles

Tom Kligerman

 shingle shade and shadow – a seaside house on Long Island

Todd Klein

 #genius

 #shinglish

119

Mike Greene

 you obviously didn't get your shingles shot this year

 Just the Pfizer.

120

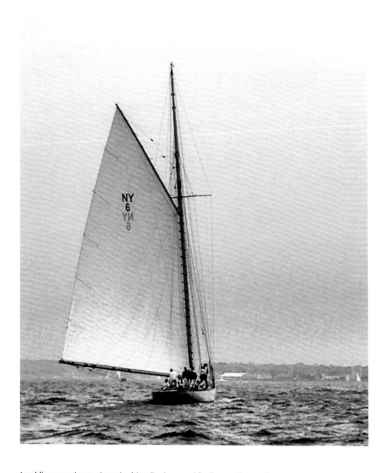

tomkligerman I was aboard a friend's sloop and feeling pretty good about myself until this spectacular gaff-rigged beauty cruised by. Not that I'm competitive ... #gaffrig #newport

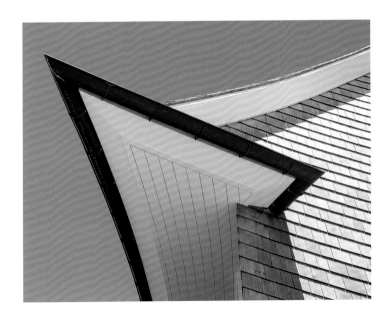

tomkligerman All about eave. #bebold

"There is always a way to
connect with someone,
even a stranger"

Tom Kligerman

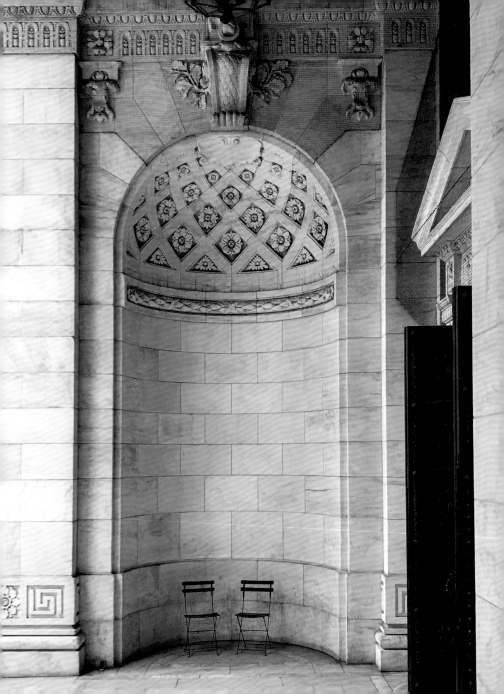

124

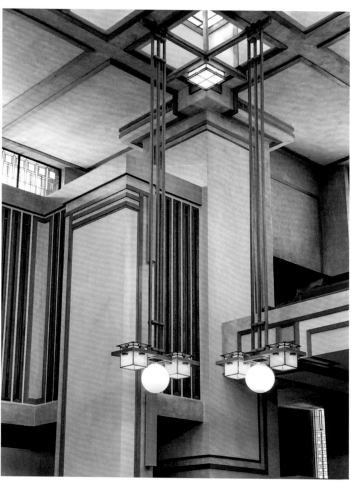

tomkligerman Unity Temple – Frank Lloyd Wright, architect, 1908.
Visiting this building reveals the extraordinary genius of Wright –
from color to materials to the use of natural light; the details and
structural sophistication – this church is spellbinding. #unitytemple
#franklloydwright

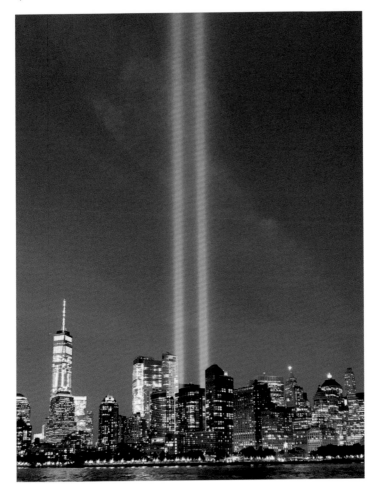

tomkligerman Beacons and blue lights. Out on the water in New York harbor on September 11th – powerful memories and powerful imagery. #remember

126

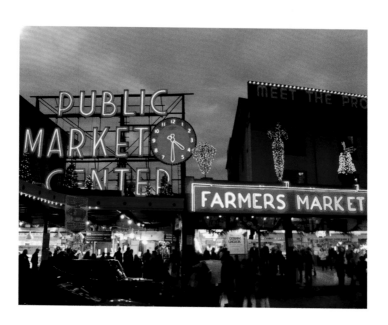

tomkligerman I ask myself with every visit to this wonderful city "Why don't I live here?" #seattle #pikeplacemarket

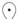

tomkligerman Strolling the city at night. I feel a Spanish sabbatical coming on. #madrid #spain #lanoche

128

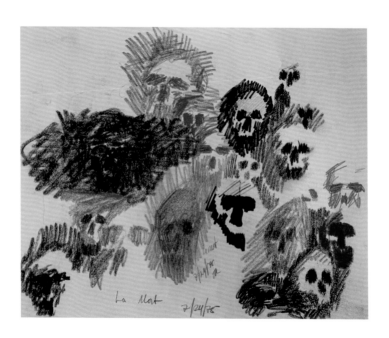

tomkligerman Teen angst.

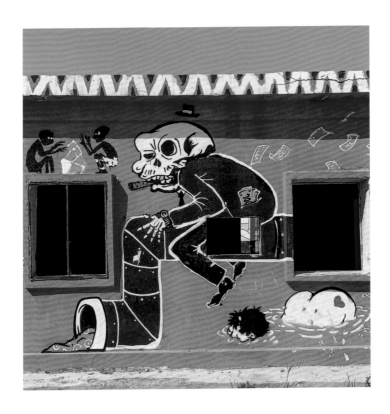

129

tomkligerman Graffiti on old army barracks in the Israeli desert.
#graffiti #skull #angst

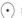
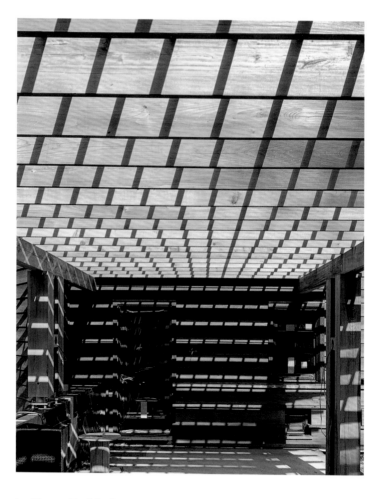

tomkligerman For all the time we spend designing a house, and as deeply as we think about it, there are always surprise moments. We study our houses in every possible way – hand drawing, computer drawing, models, material samples and full-scale mock-ups. I tell my clients I want surprises to only be good ones, like the shadows from this pergola at a house in the Blue Ridge Mountains. #shadeandshadow

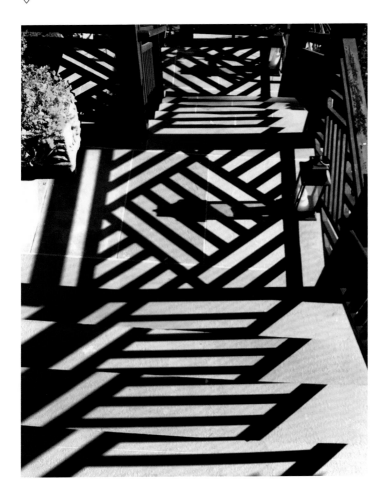

tomkligerman Chippendale handrail and bluestone steps – sunlight does the rest. #chippendale #sunlight

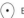
132

tomkligerman The stepwell – M. C. Escher in ancient stone. As the water table rises and falls throughout the year with the dry and rainy seasons, there is always access to water. Unfortunately these stepwells are being destroyed – some even being covered over for parking lots. #stepwell

 Century City, Los Angeles, California

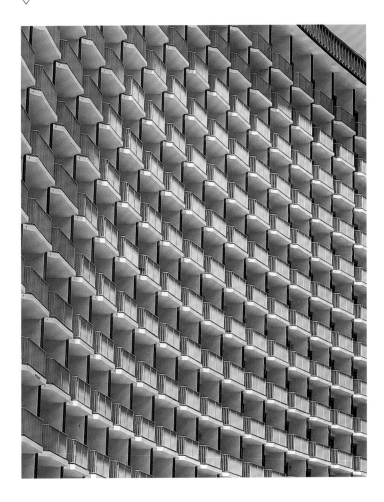

133

tomkligerman Balcony fever – can we talk about anonimity? I nearly got arrested taking this picture! #centurycity #hotel #doitforthegram

The Whisky
Watercolor Club

My mother would always give us a sip of her drink. It tasted smoky, it was good. I was about six years old and this was my first exposure to the wonder of cocktails. What I loved more than the taste of the scotch, my mother's preferred drink, was the ritual. It was something my parents did every night, a time for them to connect and talk about what had happened during the day: a synapse as well as a pause. This suspended period of time is what makes cocktail hours so pleasant to people everywhere. There was also the excitement of the esoteric elements to the ritual, such as my father's secret recipe for martinis. As a scientist he had done a dose response curve on unsuspecting guests to judge the right balance between the ingredients. We had a yachting flag that we would hang up in front of the house when we gave cocktail parties; it had a martini glass silhouetted on it which meant that drinks were served.

Every aspect of the world of cocktails breathes elegance. You get swept up in the romance, become Fred Astaire. I love nothing more than simply sitting in front of a beautiful bar. Long ago I designed one for The Buffalo Club in Los Angeles, and it's still going I'm pleased to say. Places like that have an atmospheric charm, somewhere you can sit and watch the routine of a top bartender like a ballet. There's not a wasted movement as he reaches all around for the bottles, glasses, ice and shaker – he can find all of them from memory, or possibly intuition. All the while he's engaged in conversation with different people, making everybody feel appreciated and loved. I'll always remember the bartender at The Big Four bar in the Huntington Hotel, San Francisco. He was beautifully dressed, kind, and had a great sense of humour – some of his jokes were filthy but he told them with such style that nobody minded. I hope to see him again.

And it isn't only the serving of the drinks. It's the journey to the liquor store, seeing all those beautifully designed bottles, talking to the people about what's good and then, at home, choosing the glassware to go with it. I treasure the highball glasses I have from William Yeoward, made from crystal. You're almost always with a friend of some sort when you're having a nice cocktail. So I have even been known to have one at lunchtime. It's a reprieve, a miniature vacation in the middle of the day.

During the pandemic the Whisky Watercolor Club was founded with a few architect friends who liked to paint. We meet weekly, have a drink, and paint in watercolor together over Zoom. At a time where in-person activities were impossible, it became a lifeline. The alcohol was like a metaphor for the conviviality of the group. Although physically separated by hundreds of miles, the fact that we were all sipping our cocktails at the same time and lifting our glasses to each other on our screens made the moment seem almost sacramental.

136

tomkligerman Purple impression of the Colosseum – one of my first watercolors and one of the quickest I ever did – maybe 10 minutes? #purplepaint #thumbnailsketch

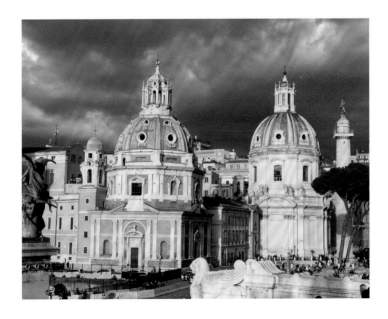

Piazza Venezia, Rome, Italy

tomkligerman Identical cousins! Golden hour in the Eternal City.

138

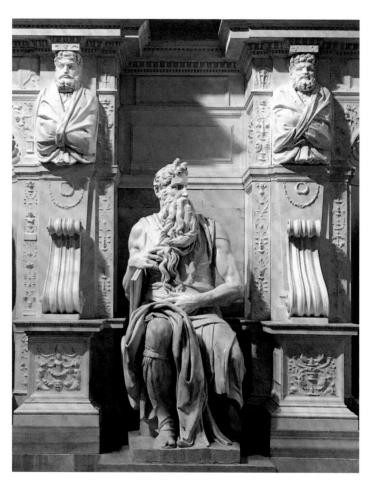

tomkligerman According to legend, when Michelangelo finished
carving Moses he hit the sculpture on the knee and said "Speak!".
Standing here in front of this man in marble, I believe it. #michelangelo

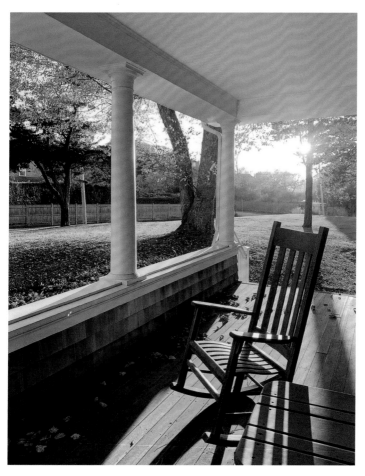

tomkligerman A quiet autumn moment #fall #rockingchair

140

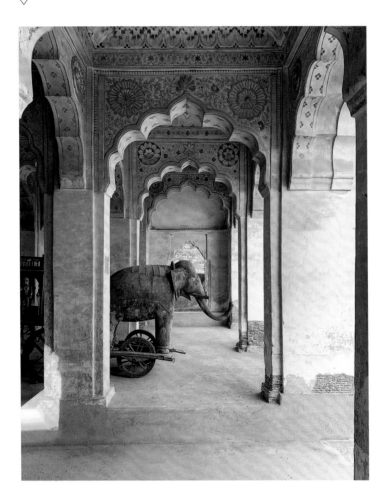

tomkligerman Nagaur Fort – my favorite of all the places I visited in India right before the pandemic shut the world down. An ancient wheeled elephant and carriage. #nagaurfort #rajasthan

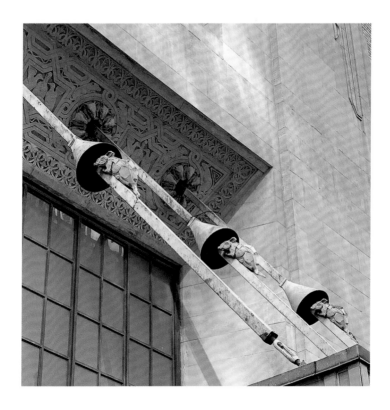

tomkligerman Rats scamper to join their friends peering out of portholes at the top of the ropes. #rats

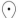
142

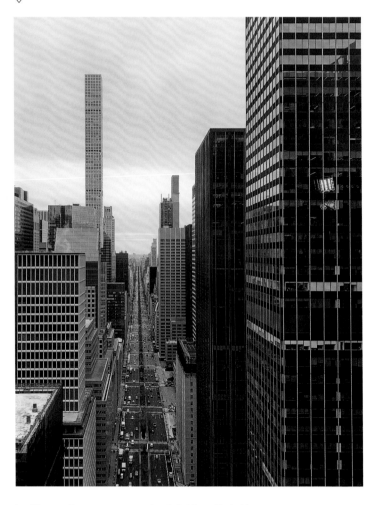

tomkligerman In case you ever wondered what it was like looking north up Park Avenue from architect Walter Gropius' sky blocking tower. #parkavenue #waltergropius

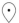

143

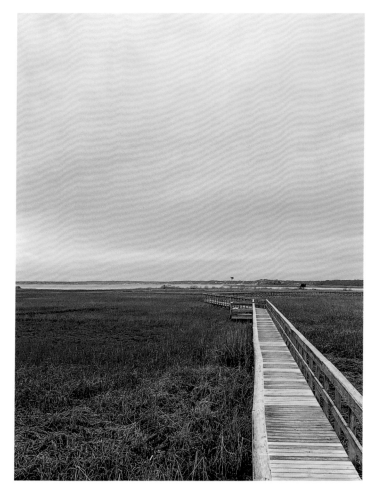

tomkligerman The Meadow Lane Boardwalk on a cold morning as I made my rounds visiting construction sites. In three months this view will be brilliant green and sparkling blue. #boardwalk

144

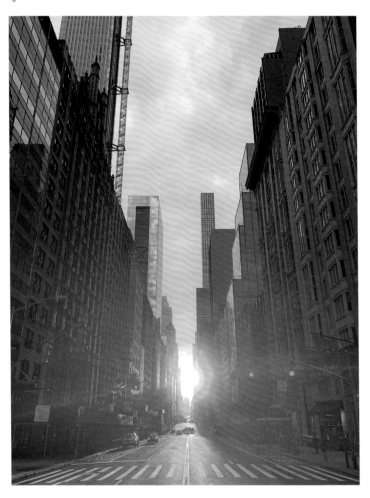

tomkligerman The ancient druids would be proud – Manhattanhenge: the blinding light at seven in the morning. #manhattanhenge

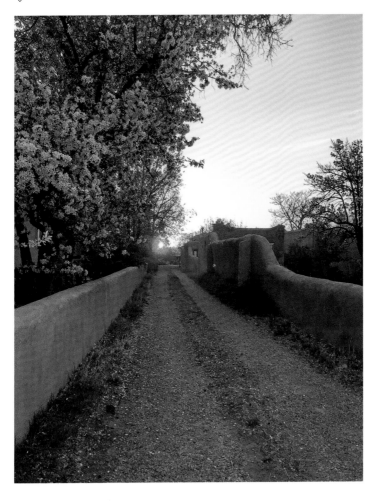

tomkligerman Adobe walls and gravel and the sun. New Mexico gets in your blood. #newmexico

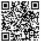

146

"There is no better way to arrive somewhere than by water"

Tom Kligerman

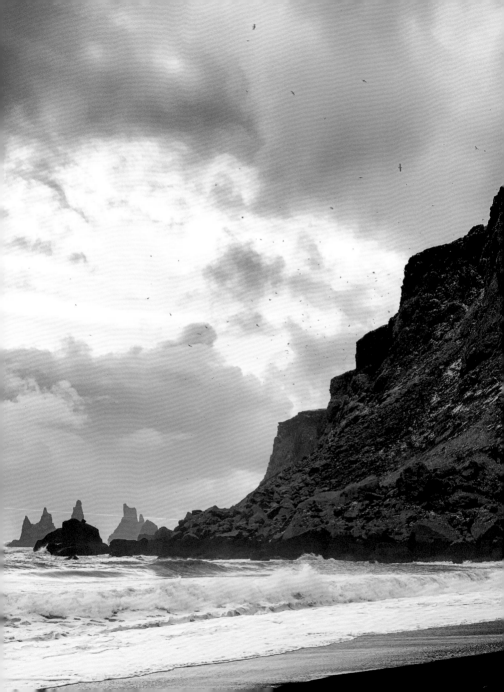

148

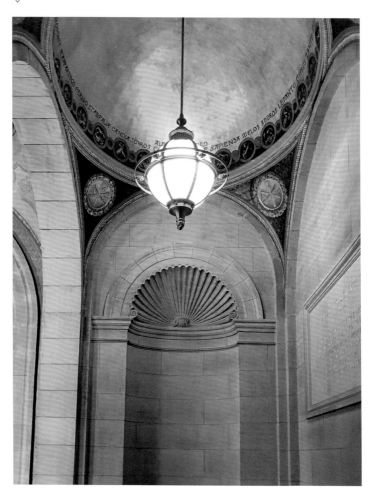

tomkligerman A gold dome at a stair landing in the Boston Public Library. No other American library compares. Architect Charles McKim (memorialized on the tablet at the right) brought together painters, sculptors, craftsman and a panoply of materials in this extraordinary classical masterpiece. #mckimmeadandwhite

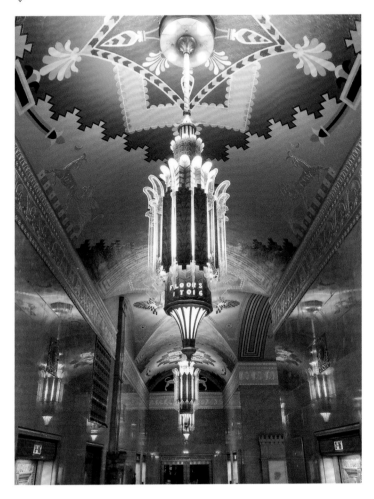

tomkligerman Deco lobby in the Fred F. French Building.
Remember – always look up! #deconewyork

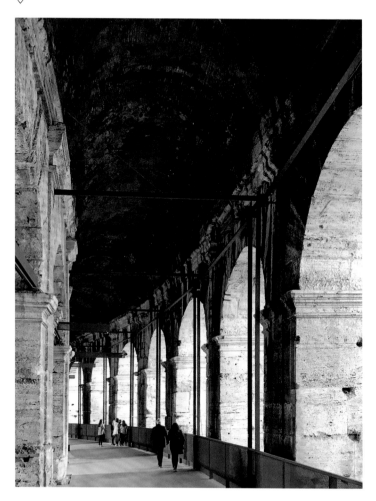

tomkligerman The vast scale and massive travertine arches of the Colosseum – I can barely imagine how this was built in 70 AD. #colosseo

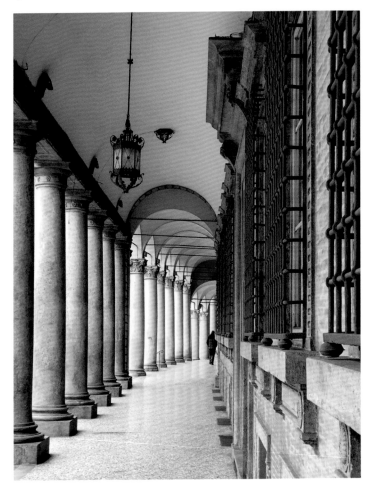

tomkligerman One of the many colonnaded sidewalks in Bologna.
If I were lucky enough to live in Italy, I would choose this beautiful city.
#bologna #emiliaromagna #colonnade

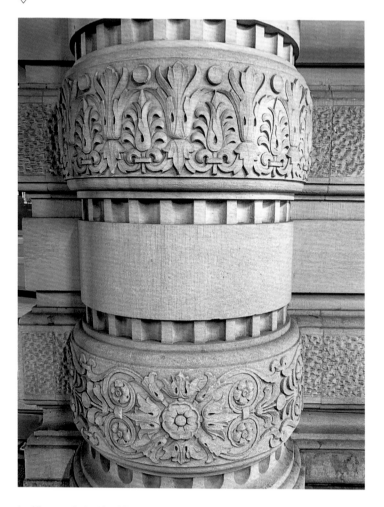

152

tomkligerman A street level flourish – carved limestone at the entrance to architect Daniel Burnham's iconic 1902 office building. #classicism #danielburnham

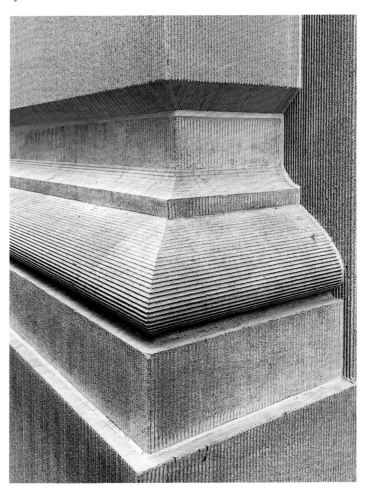

tomkligerman I am not easily bored – there is something amazing to see no matter where you are and what you are doing. Look at the carving on this pilaster base … #carvedstone #stayalert

154

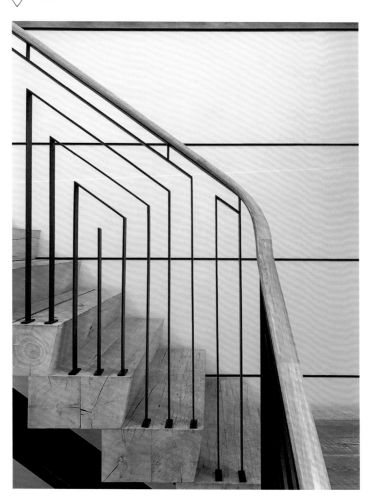

tomkligerman Modern meander in a house I designed – how spare can you get and still evoke a sense of traditional design? #maeander #timber

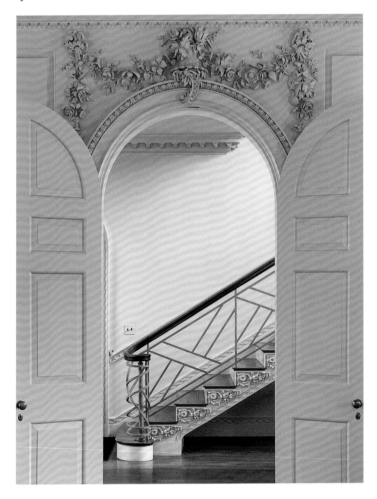

tomkligerman Philip Trammel Shutze, 1929 – a little of this and
a little of that but more than just right. #red #vitruvianscroll

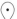
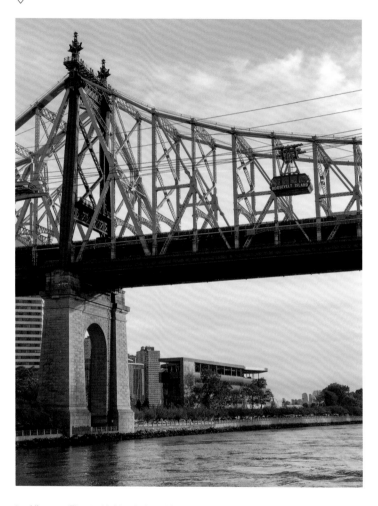

156

tomkligerman The steel bridge design of Gustav Lindenthal and Henry Hornbostel. In addition to impressing you with my historical knowledge, I just like saying their names. #queensborobridge #eastriver

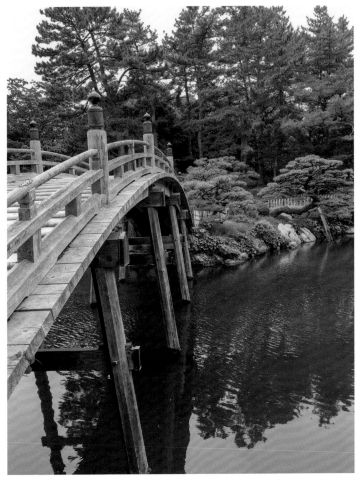

tomkligerman The quiet essence of Japan. #bridge #hinoki

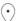

158

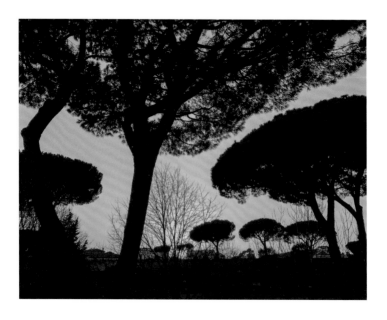

tomkligerman The umbrella pines of Rome – I miss these majestic trees and the city beneath them. #stonepine #umbrellapine

tomkligerman Fan vaults above the Dining Hall stairs. Ultimately, masonry buildings are just one stone piled on another. But look at this pile! #oxford #fanvault #englishgothic.

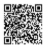

The Oyster is
My World

The first time I had an oyster was in 1960 when I was three years old. My parents had taken a house in Maine in a beautiful forest overlooking the water. My father decided to cook lobsters for dinner, which I really loved, and to also make oyster stew. Oyster stew sounded pretty cool to me. It consists of oysters, milk, butter, salt and pepper: a simple dish and the most disgusting thing I'd ever tasted.

My father loved oysters. He would go to the New York City Oyster Bar and easily order three dozen on the half shell. I tried and tried to eat oysters. I told myself it would be sophisticated. On the first date I had with my wife I wanted to show off by ordering oysters on the half shell and only just managed to get through them. Eventually I told myself my disinclination was absurd. I'd had a similar block about public speaking until one day I decided, 'this is just an irrational fear'. So I forced myself to conquer the fear of the podium and succeeded. I realized I'd have to apply a similar strategy to oysters. It was going to be them or me and luckily I came out on top. That happened about a year ago for the simple reason that I wanted to join the Billion Oyster Project, something preposterous if I would never have been seen eating an oyster.

This all feeds into the environment. I read a book called *The Big Oyster* by Mark Kurlansky about the oyster in New York City. In 1609 when Henry Hudson came sailing in, half the oysters in the world existed in New York harbor, and were eaten gratefully by European settlers and visitors of all sorts. New York City pollution ensued and all the oysters almost died out. Their absence was felt – oysters filter the water at a rate of 50 gallons of water per oyster every day – without them the pollution worsened. BOP

is an organization that is reintroducing oysters into the New York harbor, and I am lucky enough to be involved with cause. The aim is as stated: to reintroduce one billion oysters. As of now we've placed around 50 million, and, amazingly, wild oysters are starting to seed themselves amidst the clean-up, something that could accelerate the effects. Oysters also make reefs which undulate at the bottom of the harbor, a formation that can stop storm surges. Oyster beds, in essence, will help to protect us against events like Hurricane Sandy: they will help to mitigate the flooding. The benefits are plentiful.

Oysters are a bellwether of water quality, only able to exist in clean water. Their presence in New York Bay is testament to an improvement in the environment. An oyster that's been living in New York harbor would be inedible due to the toxins they've soaked up while filtering; but put them in clean water for a few weeks and all the toxins are flushed out. Cole Porter wrote a song called *The Tale of the Oyster*, about an oyster who traveled from Oyster Bay to the Park Casino, was eaten but is returned to his natural habitat when the woman who has swallowed him goes home on her yacht in rough seas. It concludes, 'Wise Little Oyster.' These bivalves have much to teach us.

162

tomkligerman Kaiseki dinner – one of 16 courses, each a surprise.
Who knows what hides beneath this porcelain lid. #kaiseki

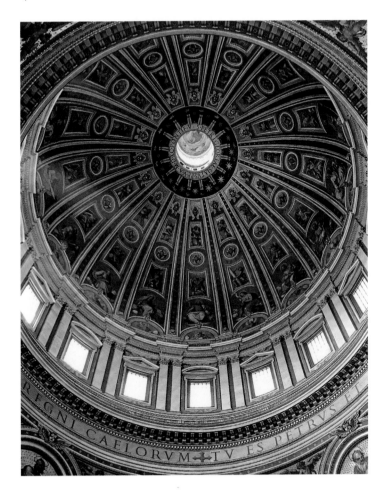

tomkligerman The great dome – all the figures and motifs are colored and gold glass mosaics. It's impossible to see that detail from the floor of the church. #thevatican

164

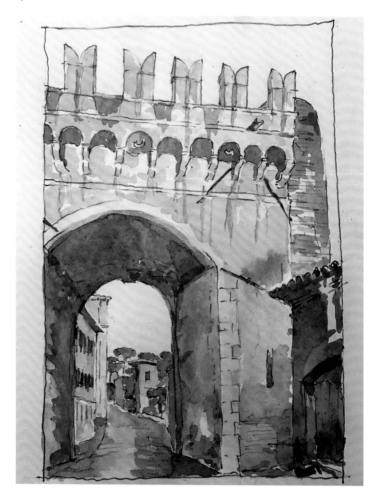

tomkligerman My first try at watercolor – a gate in the Aurelian Wall as
it crosses the Via della Lungara. #portasettimiana

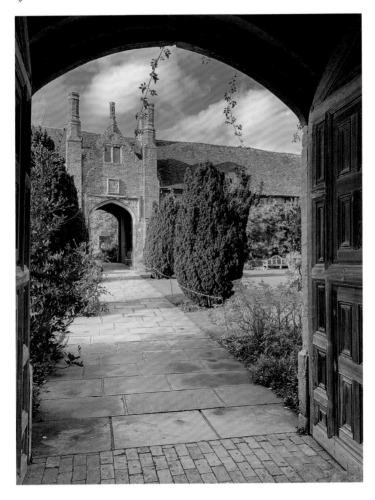

tomkligerman One fine morning – looking through the arch into the
Top Courtyard at Vita Sackveille-West's magical gardens. #sissinghurst
#wealdofkent #romance

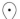
166

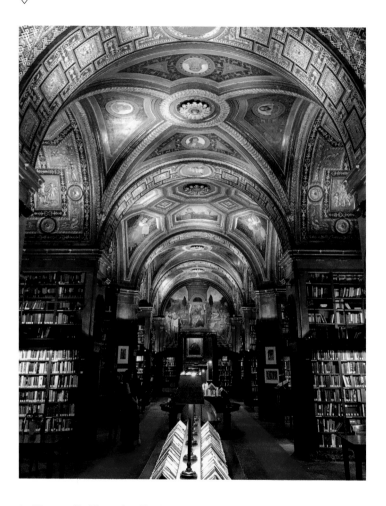

tomkligerman The Library – breaking the rules: no photos allowed.
Too late … It was a number of years before the murals were painted
on the vaults of this library. At first they were painted a simple white.

tomkligerman Polychromy – the vaults of the Parma duomo. One of my favorite churches in Italy – so much color cloaked in an austere exterior. #duomodiparma #parma #groinvault

168

tomkligerman Griffin – the name for my next dog. #istanbul #griffin

○ Palais Garnier, Paris, France

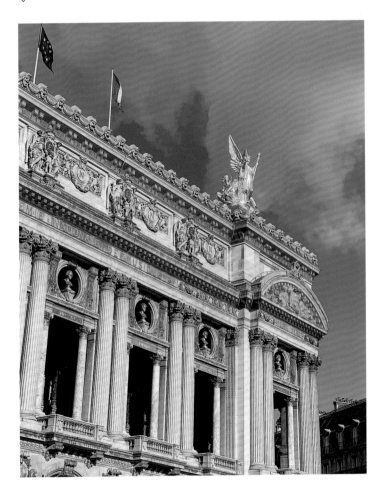

169

tomkligerman I know Paris has a new Opera House in the 12th Arrondissment but this will always be my favorite. I saw Giselle performed here when I was 16 – an etched memory.
#palaisgarnier #opera

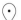
170

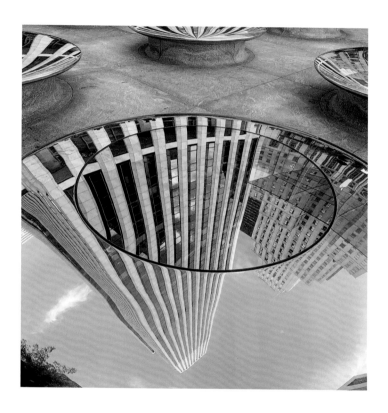

tomkligerman Magic mushrooms on the plaza above the Apple Store —
GM Building reflections.

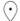

171

tomkligerman Shinier than new – a 1959 Chevy Impala – my favorite finned automobile. #chevy #fiftiesstyle

172

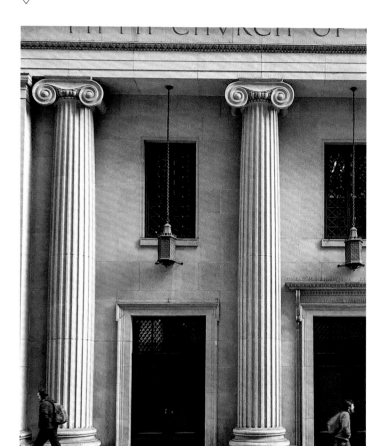

tomkligerman Passersby #thefiveorders

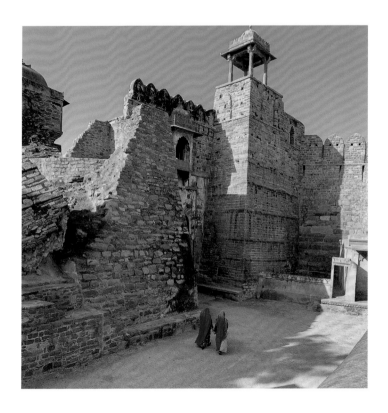

tomkligerman Arriving for work – a view of the tumble down walls at the entrance to the fort. #rajistan

174

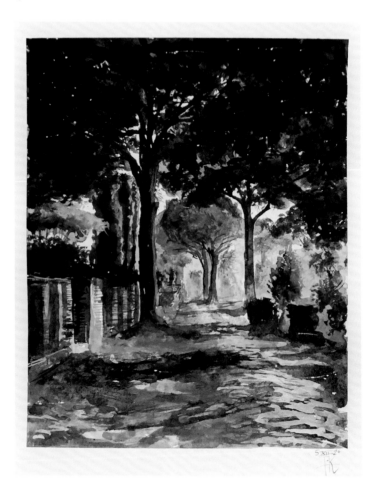

tomkligerman My watercolor inspired by a handsome photo
posted by @rhbirdwell

 Whisky Watercolor Club

Tom Kligerman

watercolor of the Appian Way

Douglas Wright

Ha? Are you in Rome?

in my mind

Ankie Barnes

beautiful colors

Steve Rugo

I 💜 Roma

Michael Imber

miss you all!

looking forward to our next watercolor adventure now that we are all vaccinated and travel ready

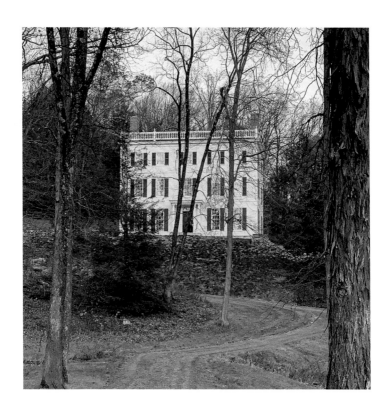

tomkligerman I slowed down to about 15 miles per hour, rolled down the window and shot this one handed – all on a dirt road. #dontdothisathome #shutters #roxburyconnecticut

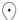

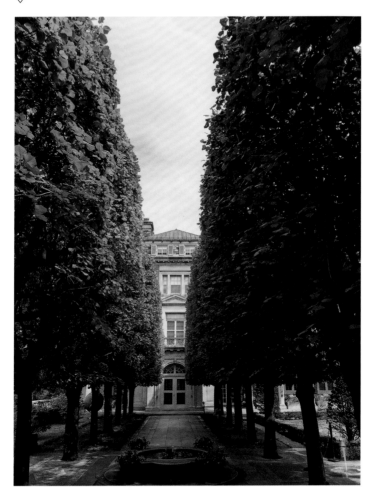

tomkligerman John D. Rockefeller's house designed by Delano & Aldrich. A house almost as amazing as the landscape by William Welles Bosworth (who also worked on the house itself). #kykuit

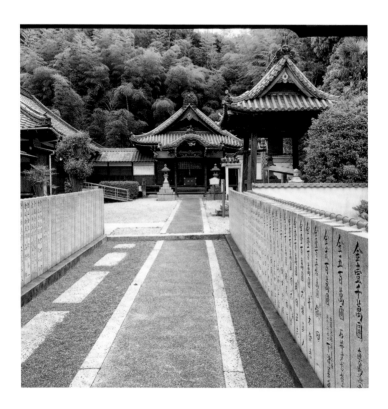

tomkligerman Hard not to feel Zen in these beautiful gardens. There is a stillness in Japan that calms the soul. #templegarden #calligraphy

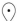
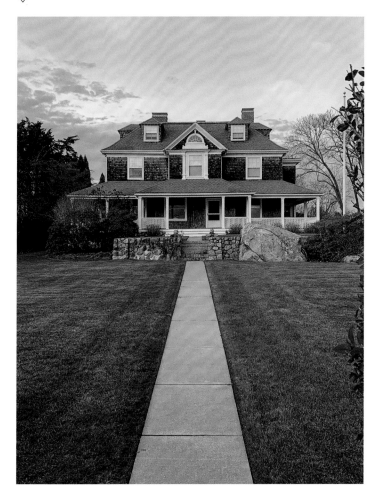

179

tomkligerman Nothing says home like a front porch – I may make a beeline for this one. By the way – have always loved that boulder AKA glaciel erratic – Rhode Island is full of them … #glacielerratic #frontporch

Bláskógabyggð, Iceland

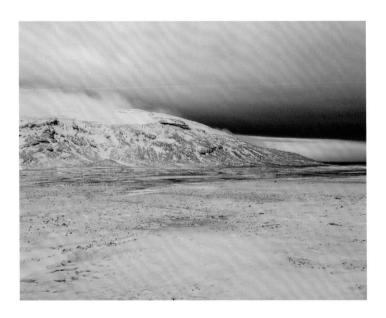

tomkligerman There are times when I am traveling around Iceland that I am convinced that I am on another planet. I've never seen more dramatic landscapes. Or explosive weather. #iceland

 Castle Creek, Colorado

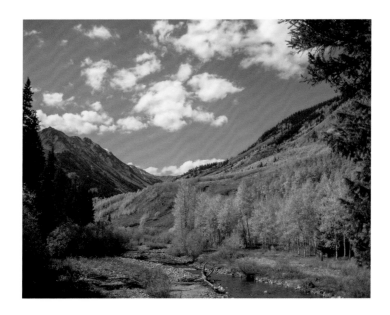

tomkligerman Fall is my favorite time in the Rockies. It has all three primary colors – yellow, blue and green. #rockymountains #colorado

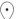
182

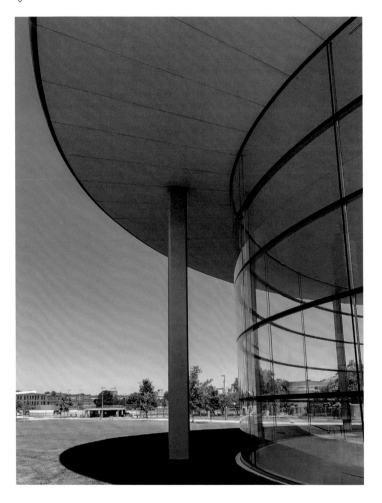

tomkligerman Cool glass, curved glass. Fortaleza Hall – a decent complement to Frank Lloyd Wright's 1939 buildings. #johnsonwaxbuilding

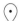
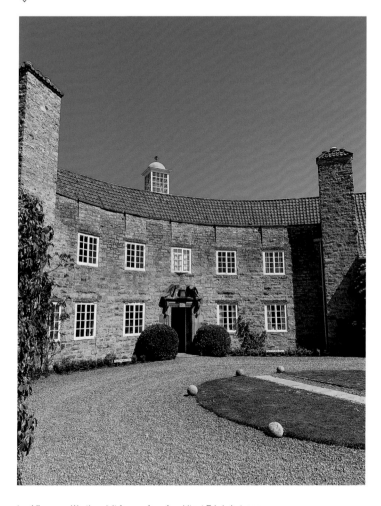

tomkligerman Worth a visit for any fan of architect Edwin Lutyens, the curved façade of Greywalls. #scotland

184

tomkligerman Red roughage. #ivy #virginiacreeper

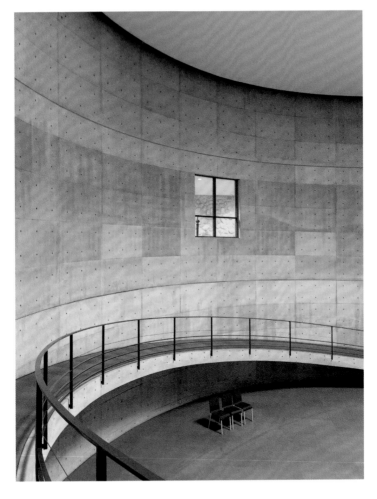

tomkligerman A little Ando in the morning – concrete never looked
so good. #tadaoando

Sculpted by Time

When I first went to Rome I expected it to be like Paris; I had been staying in Paris as an exchange student at the time and that is where the train had left from. When we pulled into the Roma Termini station I instead saw the umbrella pines, just as they are in Renaissance paintings, and the enormous ruins in the background. From that moment I have always loved ruins. The sheer weight of them is magnificent, standing next to something so massive is incredibly powerful. A historian looks at ancient ruins and sees Julius Caesar addressing the Senate. An art historian imagines how the marble would have looked on the outside when they were new. What I see is how sunlight plays across the hulking shapes, how deep-cut openings create shade and shadow, how the three-dimensionality of the form is emphasised and becomes dramatic. These are qualities I try to get into my architecture. Ruins are a form of abstract sculpture, rooted in history.

After Rome I went back home to New Mexico, another place full of ruins. In the northwest of the state Chaco Canyon used to be a fertile valley, hundreds of years ago, that eventually dried up. The people moved on leaving behind pueblos that had been built of flat pieces of sandstone, stacked on top of each other like bricks — which makes them look somewhat like the ruins of Rome. The Regency architect John Soane wrote about the clear, bright sunlight of Italy. In New Mexico the light is even more intense because it is 6,000 feet above sea level, sharpening the shadow lines and making the darkness seem more intense. The best time to visit the pueblos is in the morning or late evening when the golden light throws the basic forms into relief, highlighting the texture of the stone. In this way, New Mexico is the American equivalent of Rome.

I take inspiration from ruins, but most of the architecture in the US is built on a wooden frame. How do you create those sculptural shapes and shadows that you find in masonry ruins? That question has been stretching my imagination over the last decade. A wing, or a porch, or a door can catch the light, and there will be shadow defining it. Light is controlled by details such as a cornice or the mullions of a window. I think more and more often about how sunlight moves across surfaces. Many of the walls in Chaco Canyon are undulating and curved, and there are round ceremonial rooms called kivas sunk into the ground. When a shadow goes across a curve it creates a beautiful shape, and when that curve is the wall of a house, which the sun may take several hours to pass over, it introduces the element of time. Music can only be experienced in time, something that is also fundamentally true of ruins. They are the product of the passage of time, and they change as the day does. The word 'awesome' is overused, but it can be used quite literally in the case of ruins.

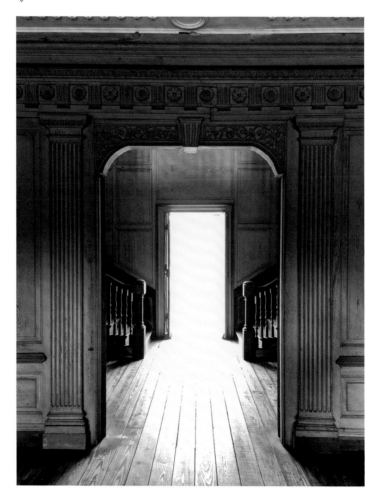

tomkligerman Into the light at one of Americas best houses.
Best house? Can you say patina? #draytonhall #timestoodstill

 East Dennis, Massachusetts

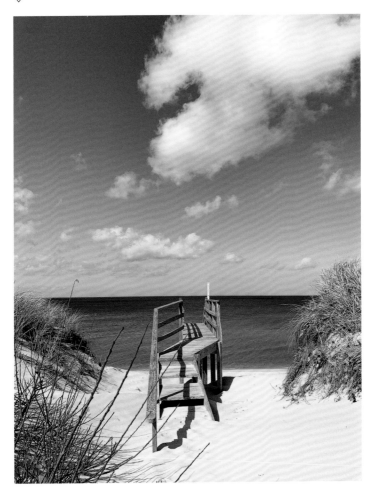

tomkligerman Imagining the smell of dune grass, hot sand, salt water and wood baking in the sun – all the things that say summer at the beach. #capecod #boardwalk #sand

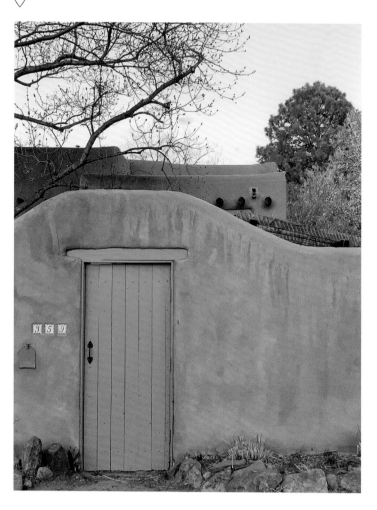

190

tomkligerman A city of walls, courtyards and surprises. #adobewalls

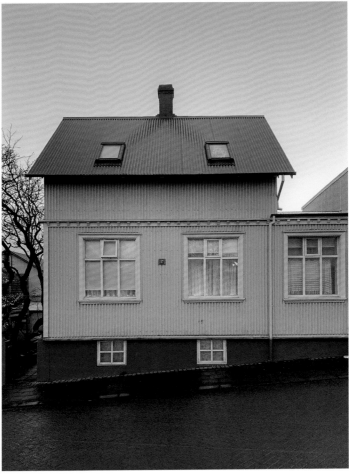

tomkligerman What Iceland suffers from in dark winters it makes up for in colorful architecture. #paintedhouses #tinroof #reykjavik

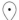 Westerly, Rhode Island

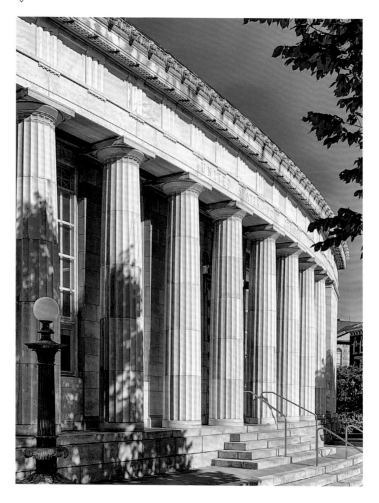

tomkligerman My favorite post office – I am struck with how even small towns could have such important civic architecture like this white marble building. #postoffice #whitemarble #civicarchitecture

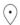
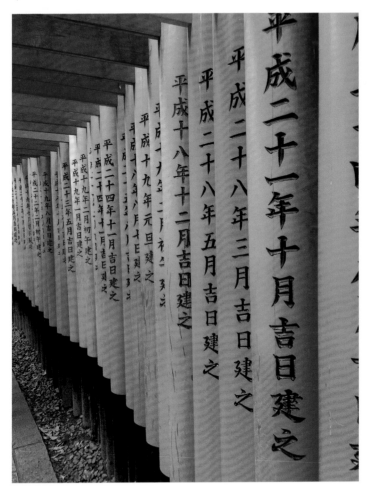

tomkligerman That wonderful feeling when you see something you never in your wildest dreams imagined that you would. I was struck by the scale of these columned walkways – my head almost touches the beams above. #shinto #shrine

194

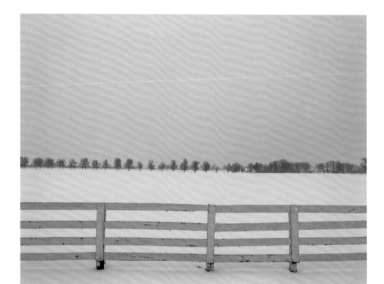

tomkligerman A color photograph maybe better described as grisaille … is that fence keeping me in or someone else out? #farm #ohio #snow #grisaille

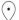
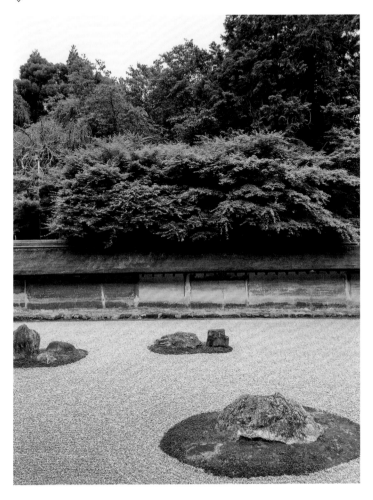

tomkligerman The control of nature – a Zen garden in Kyoto, a beautiful city with over 1,600 temples. This is just one of them. #kyoto

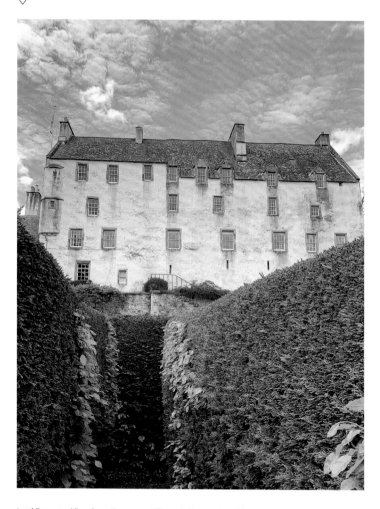

tomkligerman View from the maze at Traquair House – I could not find my way out and was left behind. So much for friends. #maze #traquairhouse

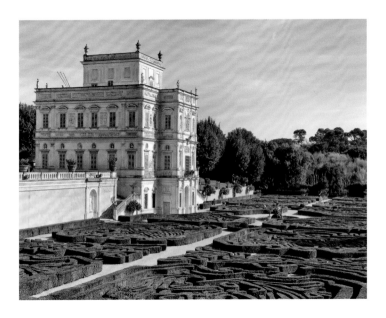

tomkligerman Morning pause – not a bad place to collect your thoughts. #villa #parterre #hedgeclipper

198

"When all else fails, copy"

Tom Kligerman

200

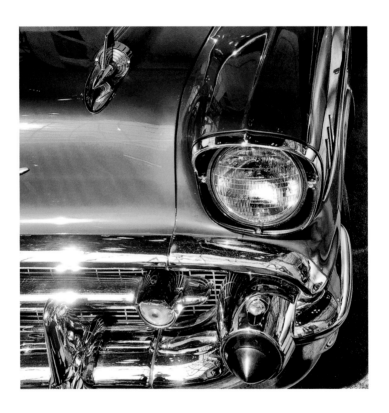

tomkligerman 1957 – a very good year for Chevrolet. #57chevy #chrome #detroitiron

201

tomkligerman Weathered wood doors at the entrance to one of my favorite buildings anywhere. This complex is one of the most layered structures in the world – and not just structurally. It is an extraordinary spiritual experience as well. Worth a trip to Israel if this was the only site you visited. #oldcityjerusalem

202

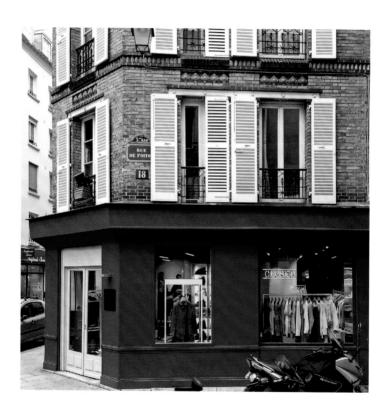

tomkligerman Bleu

St Giles Cathedral, Edinburgh, Scotland

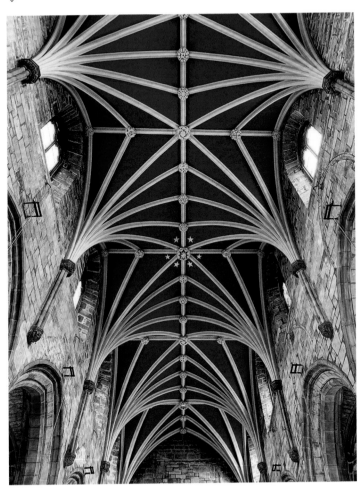

203

tomkligerman Blue

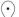
204

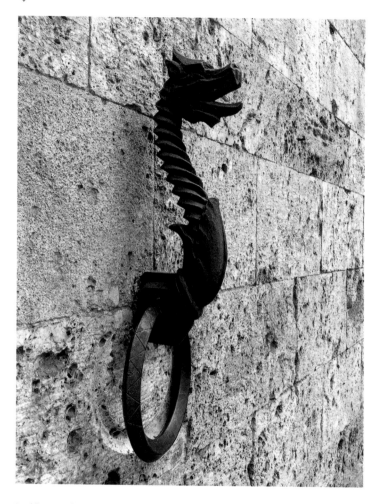

tomkligerman Scary little iron dude – taking his job very seriously.
#dragon #siena #ironwork

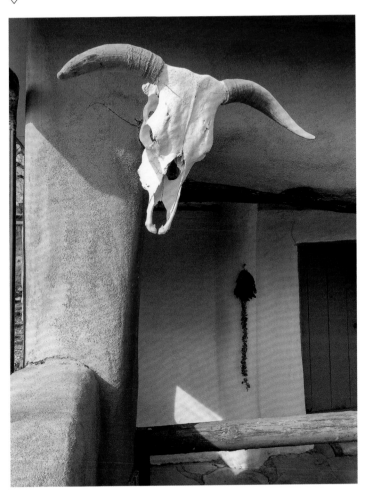

tomkligerman A western welcome at Ghost Ranch. #georgiaokeefe #ghostranch #ristra

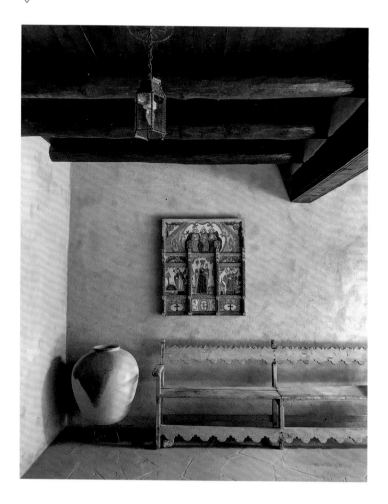

tomkligerman Spanish influence – simple furniture and a retablo at the entrance to the main house. I have visited this building many times in its current guise as a wonderful hotel and previously when it was in private hands. #albuquerque

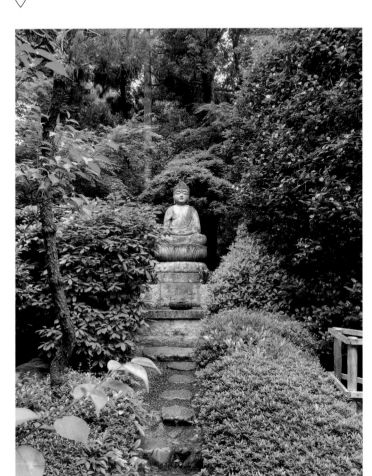

tomkligerman Buddha in the midst – a serene stone presence #buddha

208

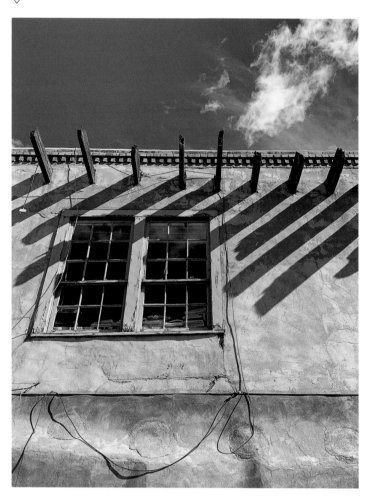

tomkligerman Land of eternal sun and blue sky. #territorialstyle

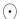

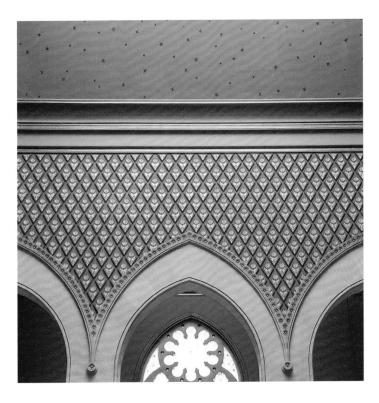

tomkligerman The genius of architect Frank Furness, 1876. The stair hall of his chef-d'oeuvre on Broad Street. Go. #frankfurness

An American Eye

For as long as I can remember I've been hypersensitive to houses. Even today I can draw the first-floor plan of the house we lived in when I was two. I can draw the plan of every floor and all the facades of the house we moved onto when I was three. My mother loved decorating, she constantly needed a new canvas; so we moved a lot, every year or two when I was growing up. One place was a constant throughout all the changes: the old Shingle Style house in Rhode Island where we spent our summers. It was not only home but part of my whole understanding of summer itself. I still love the period of architecture from which it came, the halcyon years of the late nineteenth and early twentieth century.

There are so many wonderful things about the homes of the Shingle Style (and the architecture it produced was largely all domestic). They are sheathed in cedar, a variety that in the rain smells different then it does on a hot sunny day. As the shingles weather, they acquire a beautiful silvery sheen. Back in my childhood those summer houses often had no plaster on the interior walls – you could see all the studs. The whole framework of the house was exposed inside. Nothing could be more typical of New England, and until I was fourteen this was my image of home.

Then I was uprooted. Torn from New England, I found myself in New Mexico. All of a sudden I was living in a home literally made out of dried mud. Although this was the 1970s, my parents had commissioned a traditional adobe structure with a flat roof and plaster-covered walls. There were funny-looking fireplaces that burnt piñon pine logs. Nothing could have been further from New England, but I realise now that I went from one specifically American habitat to another. The "Shingle Style"

isn't found anywhere else in the world. The same goes for the indigenous architecture of New Mexico. I now see that this was unusual. So much historical architecture in the US is based on European precedents, but fate had exposed me to two distinctly American ways of building that conditioned my eye.

Over time I have come to be fascinated by the idea of blending those two American styles together, combining what I respond to in both of them. I love the wood buildings for their thin framework, thin walls and taut surfaces. I love the architecture of New Mexican buildings for the massiveness of the masonry and the thick walls and the deep-cut windows. My ambition is to create a new American style that combines these two existing ones. When I look at the architects I admire, such as Sir Edwin Lutyens, Sir John Soane and McKim, Mead & White, it is for inspiration in their work that can help me realise this fusion. So I travel a lot, I see many buildings, I put numerous images on Instagram – but always with an American eye.

212

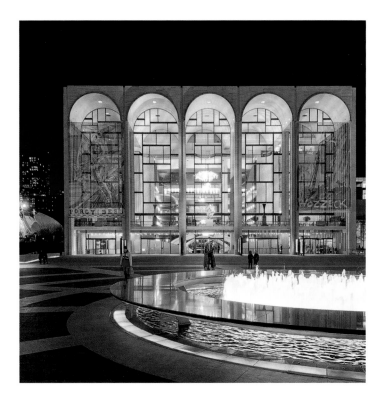

tomkligerman Opera anticipation at Lincoln Center – the splash of
water soon to be replaced by the music of Verdi. #opera #lincolncenter
#metropolitanopera

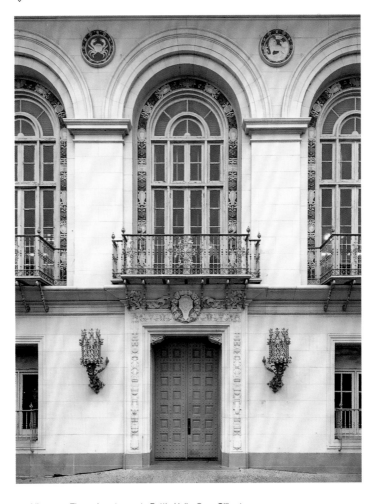

tomkligerman The main entrance to Battle Hall – Cass Gilbert, architect, 1910. Once the library for the whole university, now it houses the architecture school's collection. A beautiful building, my favorite on this wonderful campus. #battlehall #cassgilbert #utsoa

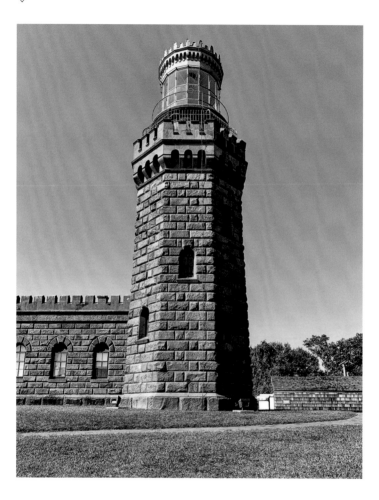

214

tomkligerman One of two lighthouses built during the Civil War high above the southernmost entrance to New York Harbor at Sandy Hook. #lighthouse #sandyhook

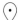

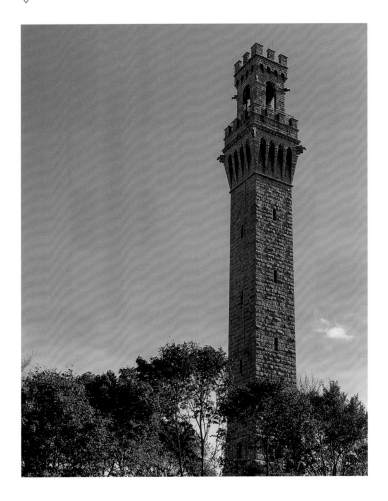

215

tomkligerman The tallest all-granite structure in the United States
– a little Siena in the sand. #torredelmangia #provincetown

216

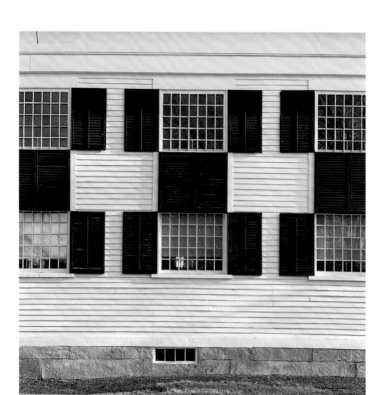

tomkligerman Checkerboard church. #shutters

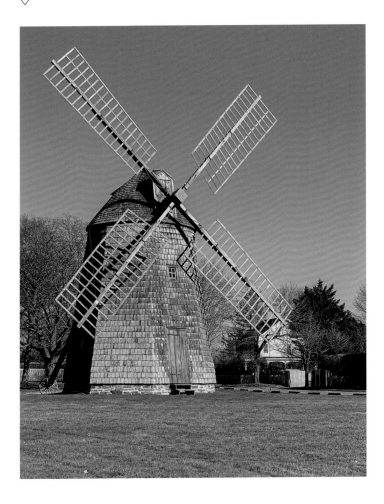

tomkligerman Why is this town called Water Mill? Why not Wind Mill?
Questions, questions, questions … #windmill #watermill

218

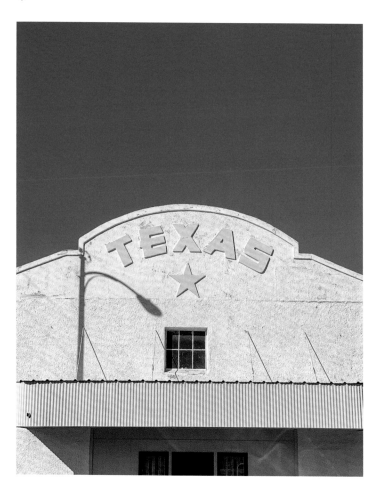

tomkligerman The Lone Star State. #dontmesswithtexas

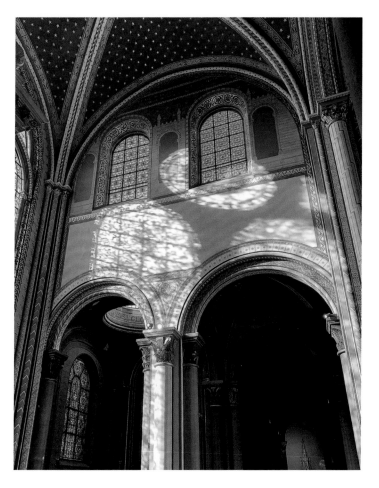

tomkligerman As if this polychromy were not enough – the play of divine sunlight. #sainteustache #stainedglass #leshalles

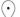

220

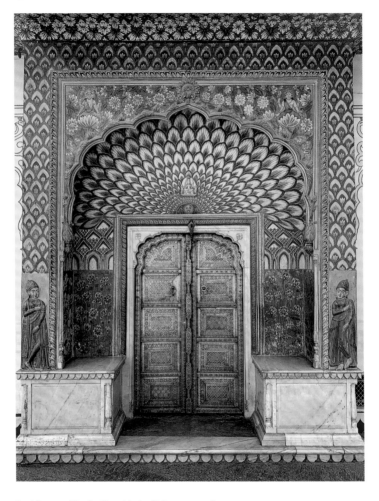

tomkligerman The Southwest Lotus Gate – representing summer
and dedicated to Lord Shiva and his consort, Parvati. #citypalace
#thefourseasons

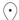

tomkligerman Terracotta gone wild – door to the Watts Cemetery Chapel, an extraordinary and highly stylized chapel designed by Mary Fraser-Tytler in 1898. Celtic meets Romanesque meets Art Nouveau greets me. #terracotta #chapel

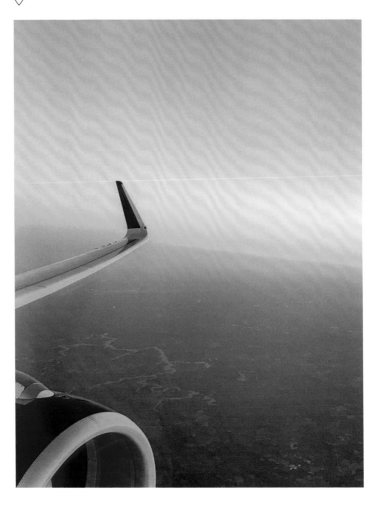

222

tomkligerman A familiar view – a place to disconnect. Knowing good things lay ahead. #airtravel

Tom Kligerman

Thinking about Christmas travel, where do you want to go?

Magdalene Kligerman

Greece or Korea or Japan or Corsica or Thailand. I want a BEACH

Katherine Kligerman

Scotland – we can stock up on Kligerman tartan. Russia?

Rebecca Kligerman

223

Warm or cold. Palm trees v the Kremlin

BTW – what is the best part about traveling?

Katherine Kligerman

Food!

Kristin Kligerman

Village squares with markets, bakeries, butchers and cheese shops

Katherine Kligerman

Crete!

224

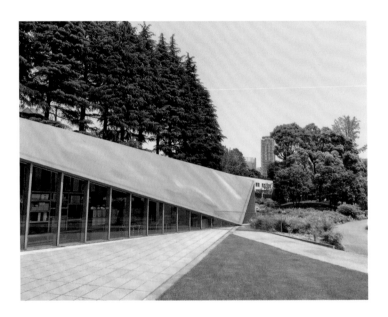

tomkligerman 21_21 Design Sight Museum, architect Tadao Ando and fashion designer Issey Miyake, 2007 – origami in metal, glass and concrete. #isseymiyake #tadaoando

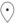 San Francisco de Asís Mission Church, Ranchos de Taos, New Mexico

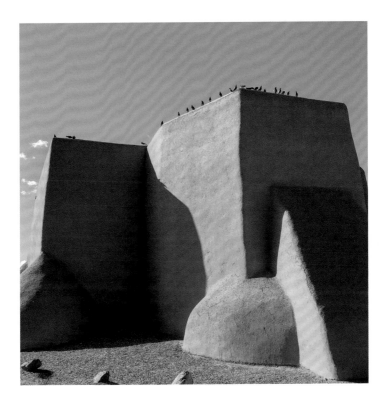

225

tomkligerman The hulking beauty of New Mexico's adobe architecture. This church has been made famous by a slew of important photographers, Paul Strand, Ansel Adams among them. #ranchosdetaos #missionchurch

226

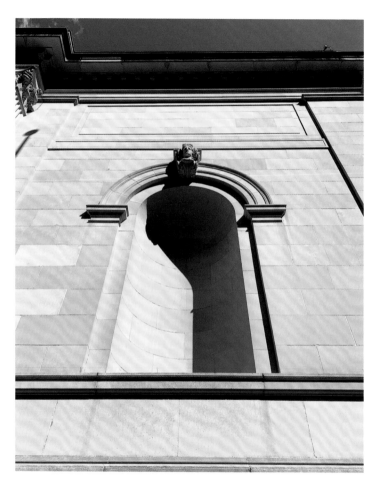

tomkligerman I can't look at this sunlit niche without thinking of projecting these shadows to create a wash rendering in the Beaux-Arts tradition. #beauxartsarchitecture

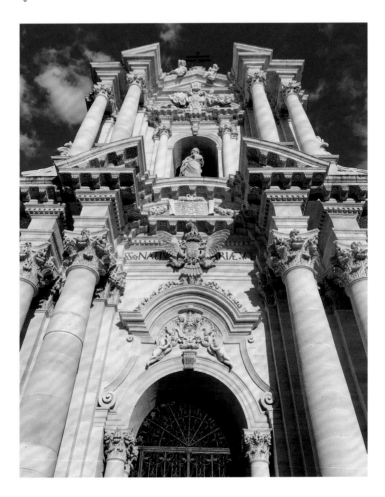

tomkligerman Behind this glorious baroque facade lies an interior dating to the ancient Greeks – massive doric columns and all. #sicily #ortigia

228

tomkligerman Hello, there!

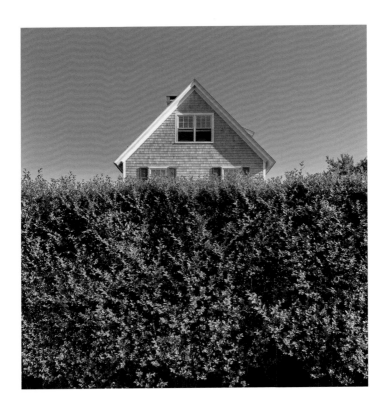

229

tomkligerman ... why, hello!

230

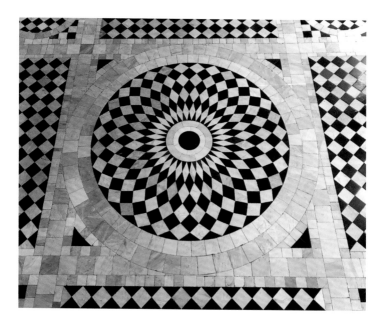

tomkligerman Black and white marble floors – you can dress them up, or dress them down. Here a floor fit for a queen. #marblefloor #blackandwhite

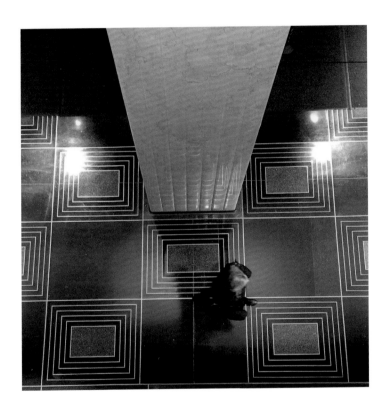

tomkligerman Best terrazzo floors in New York City – always look down … #terrazzo #passerby

232

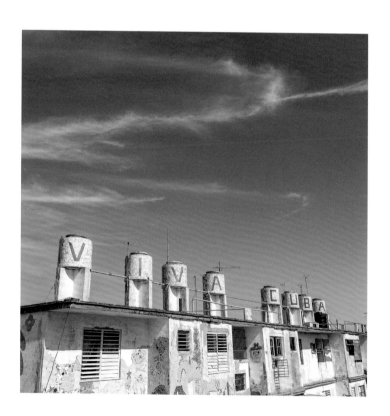

tomkligerman Colorful paint and hand written slogans like this abound in the Cuban capital. #vivacuba

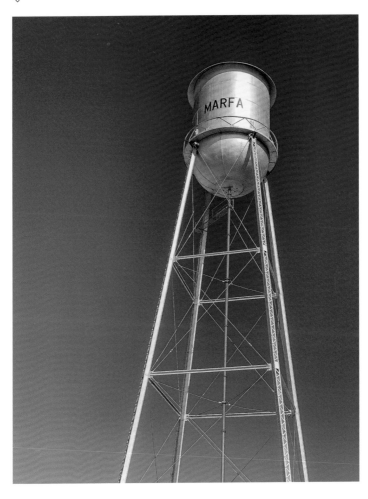

tomkligerman The town water tower – a silver contraption in the Texas sun – I keep thinking it is about to take off to the moon.
#watertower #marfa

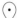
234

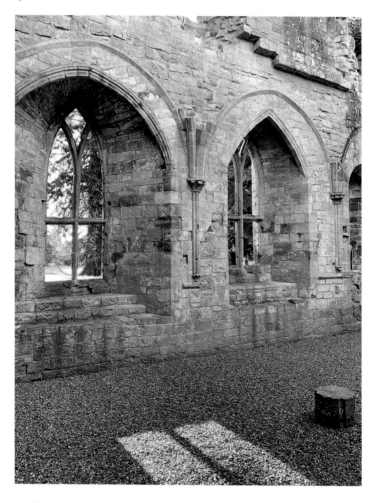

tomkligerman The romanticism of Dryburgh Abbey – can you say
Sir Walter Scott? #sirwalterscott

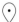

tomkligerman Wake up, travelers! Christopher Janney's rainbow
blast, Harmonic Convergence – the best part of renting a car at
Miami airport. #rainbow

Acknowledgments

I love everything about books — reading them, owning them, organizing them, just gazing at them and, from time to time, writing them. So many people have helped with this one.

I would first like to thank renowned architectural critic and historian Clive Aslet and master photographer Dylan Thomas, founders of Triglyph Books. I am grateful they tapped me for a book that combines so many wonderful things — photography, travel, architecture, landscapes; pretty much anything that can be captured by a camera phone. And this volume could not have been done without the keen eye and kindness of Ines Cross nor the thorough organization of Kate Turner, the other part of the Triglyph team that makes it all happen.

Many thanks to Steve Turner for his nearly infinite range of ideas and this dynamic, colorful design.

Erik Perez and Catherine Santonacita at @hellogroup helped fashion this story with their usual imagination and enthusiasm — thank you.

Grateful to Nancy Greystone — who has helped bring to life projects like this one through numerous in depth discussions over the past few years.

Sara Frantz — endless thanks. This volume and so many other things would not be possible without her care, insight, common sense and hard work.

I would have been lost without my international team of advisors — Jamie Dworkin, stateside, and my sister, Valli Budestschu, in Paris.

Their comments and advice have been invaluable and have helped shape this book.

To those I am so lucky to be surrounded by: many travel companions; colleagues in the design world – architects, interior designers, landscape architects, contractors and artisans; magazine editors and writers; clients and friends; whether you know it or not you are always with me on my travels and, though out of sight, part of this book.

And to my daughters, Rebecca, Katherine, and Magdalen who brainstormed and critiqued as only family members can do with a stream of gentle barbs and inside jokes. Finally, thank you to my wife, Kristin, who helps keep all things in perspective with steadfast and loving support.

Santa Fe, New Mexico. April, 2021

Biography

Thomas A. Kligerman is an accomplished architect based in New York City. He was raised in a New England college town before moving to the high desert of New Mexico. Tom is an extensive traveler, having lived in France, England and most recently at The American Academy in Rome as a visiting scholar. From Japan to Cuba and Iceland to India he continues to make his way around the world. His work combines traditional and modern design and has been published in two monographs, *Ike Kligerman Barkley: Houses* and *The New Shingled House*. When not traveling, he enjoys cycling, water coloring, classic cars, cocktails and spending time with his family escaping to the coast of Rhode Island.

First published in the United Kingdom
in 2021 by Triglyph Books.

Triglyph Books
154 Tachbrook Street
London SW1V 2NE

www.TriglyphBooks.com
Instagram: @TriglyphBooks

Designed by Steve Turner.

239

ISBN : 978-1-9163554-6-0

Printed and bound sustainably in Italy.

AS I SEE IT
A Life in Detours

And the journey continues…

@tomkligerman / Architect

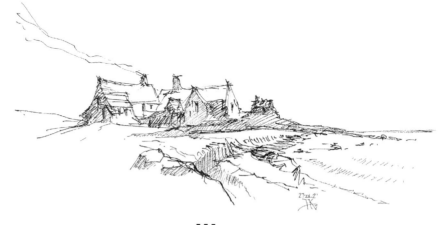

TRIGLYPH
BOOKS